REVISIONS:
an alternative history of photography

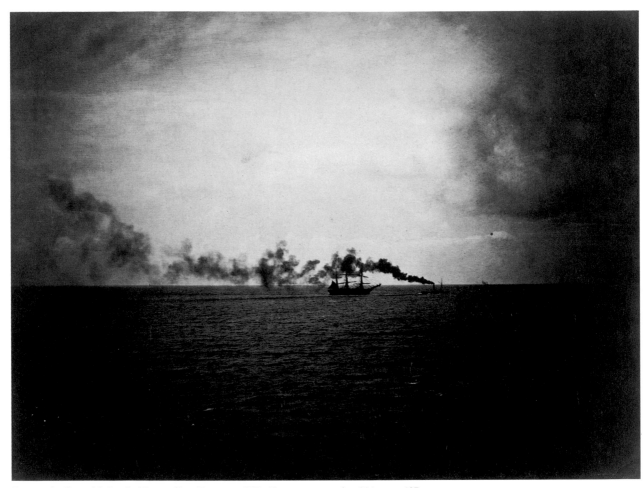

Gustave Le Gray. *Marine, Le Vapeur*, Sète, France, *c.* 1856. Albumen paper print. 304mm × 407mm
(Michael and Jane Wilson, Wilson Centre for Photography)

REVISIONS:
an alternative history of photography

Ian Jeffrey

The National Museum of Photography, Film & Television is part of the National Museum of Science & Industry

Exhibition shown at the National Museum
of Photography, Film & Television
16 April – 27 June 1999

Contents

Foreword

The National Museum of Photography, Film & Television opened in Spring '99 after a massive re-development. An important part of the new Museum is a spectacular special exhibition gallery, specifically designed to meet the most demanding conditions for major exhibitions of photography, film and television. *ReVisions* is the opening exhibition, and is one which underpins the intellectual rationale behind the Museum's permanent galleries, education programmes and film exhibitions. Drawn mainly from the Museum's collection of photographs, *ReVisions* asks you to think again about the accepted understanding of photographic history.

This is a large exhibition, large in the sense that it takes a broad collective sweep across photography, releasing it from categorizing ghettos of art or science. In so doing, it re-presents the history of photography, holistically, taking collective ownership of photography's many diverse and splendid applications. Ian Jeffrey proposes a new and powerful history of the medium. He presents a treatise which identifies both technical and aesthetic advances which have played a specific part in driving forward the photographic agenda, some hitherto ignored or even dismissed as trivial. Each advance is considered and justified within the broadest social, scientific, aesthetic, even literary context and through this he demonstrates how photography and the 'unconscious' culture are inseparable.

Amanda Nevill
Head of Museum
National Museum of Photography, Film & Television, Bradford
April 1999

Preface

This exhibition, as displayed on the walls of the National Museum of Photography, Film & Television and outlined in the catalogue which follows, has to be justified, because it contains a lot of material not often considered in histories of photography, and which is even alien to such histories. Its theory is of a steady state in photography disrupted, during the nineteenth century, by new formats suddenly and unexpectedly introduced and, during the twentieth, by startling and outlandish subject matter of the kind generated by war and technology. The theory also goes on to suggest that the material deposited in art's inventory during these moments of crisis and amazement constitutes photography proper, and with better claims to that position than anything produced by the medium's major artists. It argues less for an 'outsider' art, in the terminology of the 1960s, than for one deeply implicated in what could be provisionally termed the cultural unconscious, an art simultaneously significant and enigmatic.

The history of great photographers and of their masterworks might look like the one which we should follow, for it is ennobling, a testament to human capacities and to the power of the imagination. It gives credit to remarkable individuals who have been able to rise above their social and cultural circumstances, in a way closed to the rest of us but one which we might have aspired to. There are drawbacks to this kind of history, the principal one being that it leaves far too much unaccounted for. There are, it must be admitted, only a handful of major artists in the history of the medium: Julia Margaret Cameron (1860s), Peter Henry Emerson (1890s), Frederick Evans (1900), Alfred Stieglitz (1900) and 20 or so more, whose pictures appear in all the recent annals of photography. A history of great artists, presuming that we can identify them accurately, is unfair to all the others. It also has to be said that most great artists in photography are outstanding for brief periods. This is because photographers have always worked unusually close to the cultural front-line, and that near to that line they have been at their most alert. Photography has been close to culture at large because its practitioners have emerged from the ranks not often thinking of themselves as artists. If painters were schooled in a tradition, photographers were something else: scientists, opticians, tradesmen or mere opportunists.

Culture, or the sum total of what is habitually carried on in society, might seem to be a concept without mystery. It can be analyzed and accounted for, and in an ideal socio-cultural history of photography, not so far undertaken, one would expect detailed reports on the growth of pictorial genres (such as Alpine scenes in the 1860s and panoramic street studies in the 1890s) and on changing trends in popular camera ownership. Studies of that kind, however, give a false impression of business as usual, or of culture as a humdrum continuum. Of course a lot of photography testifies to culture as a steady state, and none more so than stereo in the late nineteenth century when predictable markets had been worked out. But there are

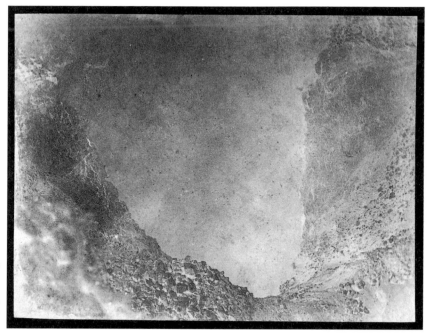

Reverend George Bridges
Taken in the crater during an explosion,
Etna, *c.*1845.
Calotype negative.165mm × 215mm
(from the Collection of the National
Museum of Photography, Film & Television)

Reverend George Bridges
A mass of running lava, Etna, *c.*1845.
Calotype negative. 165mm × 215mm
(from the Collection of the National Museum
of Photography, Film & Television)

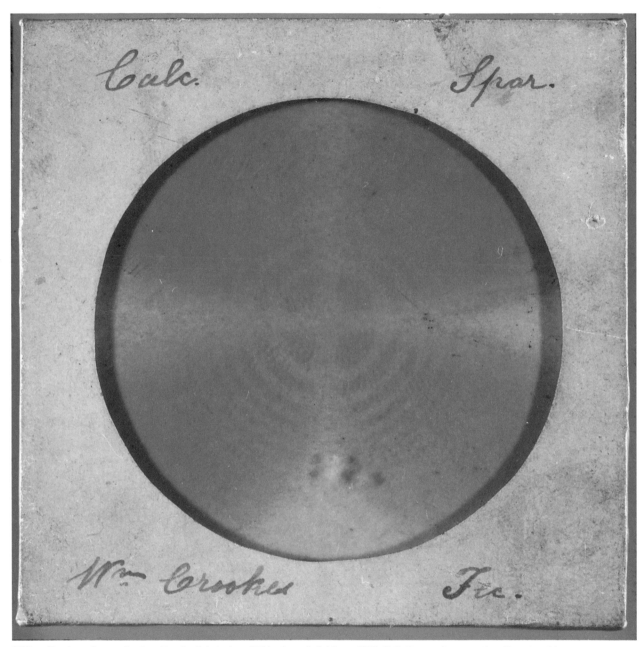

William Crookes. *Pattern Produced by the Polarization of Light through Calcite, c.* 1852. Collodion on glass negative. Diameter: 44mm (from the Collection of the National Museum of Photography, Film & Television)

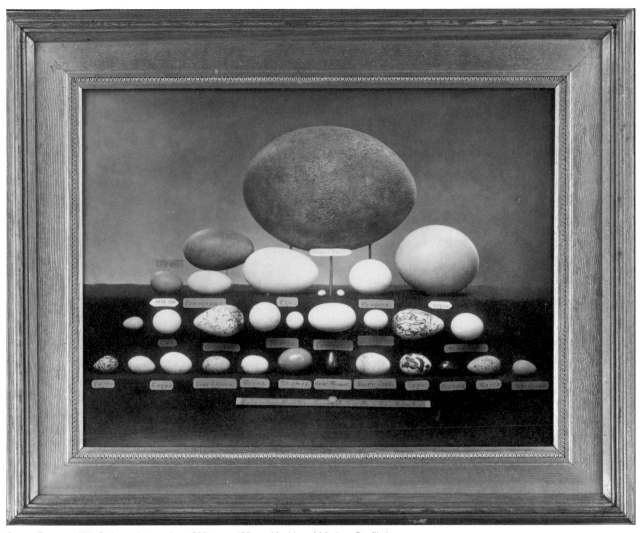

Anon. *Eggs*, *c.* 1880. Carbon print on glass. 292mm × 432mm (Archive of Modern Conflict)

other deep-seated aspects to culture about which we can be far less confident. Beneath or beyond the level of practice lies something which might be called the collective unconscious, or a shared state of mind subject to unfathomable wishful-thinking and to fears. This other world has preoccupied photography, less because photographers are of an innately surrealist turn of mind than because they have mostly been in a position where they have had no option but to respond to the cultural flow as it happens. Their responses have often been determined by basic needs, headed by the need to survive; and this has forced them to test the market, or the public aspect of the collective unconscious. Testing the market, as in the early stereo age around 1860, meant experimenting with new genres in the hope that one would catch on. Not knowing what sort of market they could rely on, photographers experimented widely, and as often as not their experiments came to nothing. Either no public emerged, or did so only for a brief moment.

What happened in photography as a result was the accumulation of an inventory or stock of what might be described as homeless imagery. Scientists and technologists used the medium for practical and non-pictorial work, to look in detail at streptococci or at the effects of nitro-glycerine on steel, and once the image had been read it was surplus to requirements. Given our reluctance to destroy pictures, hordes of them have, as it were, lain in wait for later cultural moments in which they would come into their own as significant motifs. This was very apparent in the 1970s when, in the aftermath of the social disturbances of 1968 and in response to the writings of Michel Foucault, a whole generation of commentators developed an interest in social control, as carried out furtively and even unselfconsciously by the liberal democracies. Identification pictures of citizens, prisoners, the mad and the marginal, which had once been collected as curios or just deposited in archives, began to figure as evidence in analyses of oppression and to take their place on photography's official lists as monitored in academe.

One set of pictures in *ReVisions* is of cuneiform script, recorded by a photographer in the British Museum in the 1850s. Its existence can be readily explained: a photographic record was easier to take and to copy than a drawing, and it would have looked more convincing too. At the same time, though, these pictures show letters solidified, lodged in material, propped and supported by wooden wedges and nails. As cuneiform they would be unreadable to any but out-and-out specialists, and thus easily interpreted as primitive epitomes of writing: text muted, text as material. In 1850 such pictures would have been seen primarily as documents; in the 1990s (and '70s and '80s), on the other hand, they could hardly have been seen apart from contemporary speculations on the nature of the sign, and read, probably, as signs either come to rest or preserved from some pure state of origin, detached from speech. They stand as monuments to the linguistic debates of the post-modern era. It is in these debates that they discover something like their intentions, or a body of opinion in which they can find satisfaction of a sort.

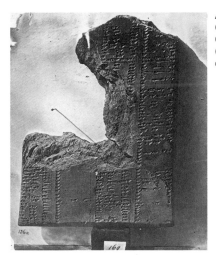

Anon
Cuneiform script in the British Museum, *c.* 1850.
Calotype. 203mm × 152mm
(from the Collection of the National Museum
of Photography, Film & Television)

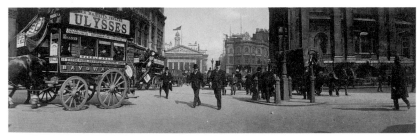

Anon
Kodak trial pictures, *c.* 1902.
Contact prints on printing-out
paper. 51mm × 171mm
(from the Collection of the
National Museum of
Photography, Film & Television)

These cuneiform tablets are an example of the sort of material which finds its way into the inventory, although they are a minor instance. Most gratuitous stock emerged, by contrast, from technical developments and the instabilities which resulted. New mechanisms and formats suddenly confronted operatives, which is how they can best be described, with the problem of a new means of representation and relatively little guidance as to what should be represented and how. These 'windows of opportunity' were quickly filled with expected views, but not before tyro operatives surprised both themselves and posterity.

These moments of startlement, some more disturbing than others, can be identified and listed, and they are the subject of the text which follows. (1) In the 1840s, when both the calotype and daguerreotype were new, there were no reliable rules of engagement, and photographers had no option but to experiment. Intentions, which has always been inherent in art-making, could now no longer be taken for granted with respect to a medium which could be exercised purely for its own sake. (2) Waxed-paper negatives and albumen printing, introduced in the early 1850s, made it possible to point to the weight of objects and to density of space as never before, and for a decade photography tended luxuriantly in this direction. (3) Photomicrography had been on photography's agenda from the outset. It made it possible to signal continuities between human sensing and the invisible world. It developed a piquant iconography of stinging and biting, wasps, bees and human fleas, and seemed to be a part of the Realist aesthetic as it was developed by painters in the 1840s and 1850s (mainly in France). If so, it is an example of practical photography going in disguise, part of an aesthetic all along, and even a major and formative part of Realism. (4) The stereo revolution, which began in the late 1850s, suddenly introduced its spectacular illusions of depth. Even though always miraculous, these pictures were never enough in themselves and stereo artists looked for subjects interesting in themselves, most notably street activity in the city. Stereo also uncovered previously unsuspected mass markets

Anon
On Manoeuvres no. 1, c.1916.
Stereo autochrome (detail).
70mm × 60mm
(from the Collection of the
National Museum of Photography,
Film & Television)

for photography, and these could only be prospected by genre experimentations, at their most adventurous in the late 1850s and the 1860s. (5) Instantaneous or snapshot photography lured inventors in the 1880s, the most successful of whom was George Eastman, author of the Kodak brand name. Eastman seems to have envisaged snapshot photography as an accompaniment to travel, and as a way of recording its incidentals. He seems, though, to have over-estimated his public's appetite for that degree of recall. (6) In the 1890s Eastman interested himself in panoramic photography, apparently imagining a public taste for episodes from city life, which was still then horse-drawn and pedestrian, and much as James Joyce remembered it in *Ulysses*. Eastman seems again to have over-estimated his market, for the panoramic movement came to nothing, apart from an exceptional body of experimental pictures taken by Kodak agents around and about in London in 1900. (7) Celestial photography, although it was as old as the medium itself, became the subject of a major international initiative in 1887: the photographic mapping of the whole heavens. Technical developments revealed stars in unmanageable numbers, but not before the public had been introduced to the nebulae, bodies forming, dissolving and above all spiralling in distant space. These wheeling figures sedimented themselves in the modern imagination, or at least in that bit of it shared and developed by poets and painters. (8) Chronophotography, developed by Eadweard Muybridge (b. Edward Muggeridge) and Etienne Marey in the 1880s, led to the development of moving pictures and to a place in History. However, it seems to have had other agendas, bearing on the deceleration and manipulation of time. Muybridge also introduced the human figure as a mechanism acting out obsessive parts in short and pointless dramas. (9) X-ray, or 'new' photography was invented or discovered more or less by accident in 1895 and its details announced forthwith. It became a dangerous craze for the next five years or so before it was understood and assimilated into medical practice. (10) Colour had long been the philosopher's stone of photography, and it was finally achieved, on a commercial scale, by the Lumière brothers in Lyons in 1907. It brought the most transient effects within range: flowers, mists, clouds and atmospheres. The Great War, with its diet of mud and gases, sated the appetite which colour had been devised to serve, and in the modernist period colour became something of an anachronism in photography.

Photography's first phase lasted until the marketing of the Autochrome in 1907. New and briefly disturbing formats emerged and disappeared in almost every decade of the nineteenth century, but this ceased to be the pattern during the modernist era, that is roughly from the time of the Great War. Photography had never previously mattered in any geo-political sense, because the means of distribution weren't to hand. The masses had not yet emerged to be pacified or persuaded, and ideological confrontations were not as acute as they would become from the 1920s onwards. The mass media which had developed from 1900 in the liberal culture then established in Britain, France, Germany and the USA were

unconstrained, and it was part of the liberal ethic that this should be so. The Soviets changed all that in the 1920s with their projections of a workers' utopia. Photographers, whether they liked it or not, were participants in the unfolding struggles between the liberal democracies and the new totalitarian orders. Photography was, in effect, collectivized.

Just as important as this ideological infiltration was the industrialization of photography. In the nineteenth century, with the exception of stereo production, photography was a cottage industry, within which individuals could still make a difference. One of these individuals, Otto Pfenninger, appears here. Pfenninger experimented with colour after 1900, but at a time when advances were beginning to be made by businesses which had the resources to invest in research and development. New mechanisms and formats continued to emerge, but in the twentieth century they took years to perfect before reaching the market. The X-ray phenomenon excitedly announced and followed up by widespread experimentation the length and breadth of Europe, was impossible to imagine in the 1920s. Photography, until the announcement of the Autochrome, had also been a coterie and even an avant-garde activity carried out by scientists who looked on other photographers and inventors as co-workers. Something of this co-operative spirit can be sensed in the reports of the Royal Photographic Society in London, published in *The Photographic Journal* around 1900 and drawn on in the texts which follow.

'Windows of opportunity', or moments of breakdown, occurred much less often in the twentieth century. Photography passed from the hands of the old scientific coteries, whose successors were employed by the research and development wings of Kodak, Afga and Ilford, into those of the operatives who serviced the newly established illustrated press, of Germany and France during the 1920s, and then of Britain and the USA during the '30s. Press photographers in the modernist era were documentarists rather than reporters; between them they refined elaborate iconographies of national and class-based types. The major difference between the aesthetic of the liberal democracies and that of their opponents was that the liberals in the USA in particular favoured site-specific staging, whereas the Russians and Germans liked to photograph representative figures in controlled, studio settings, even if these were ostensibly 'out of doors'. The new world orders imagined by Fascist and Communist moderns were to be peopled by types rather than by individuals, for individuals were by definition unbiddable and unassimilable, or part of the old order of localities, parishes, common and case law.

Liberalism triumphed, more or less, in 1945, and set about the work of securing its triumph. It was to be liberalism on a world scale, ignoring for the time being the survival of the USSR. To do justice to the singularity of peoples everywhere was a gigantic task, and one with internal contradictions, for the very idea of 'a people' was dangerously exclusive. Thus the documentarists of 1945 and after gave as profuse reports as possible, so that the idea of a nation or of a tribe might

be lost sight of within the general ideal of nationhood. *The Family of Man*, a vast exhibition assembled by New York's Museum of Modern Art in 1955, exemplifies this movement in photography. The liberal project was visionary; a 'family of man' living tolerantly together, respectful of racial and generational differences. It made no allowances for solitude, social breakdown and evil, and didn't like to think of itself as containing recluses, deviants and anti-social elements, with the result that these became interesting to new photographers tired of the old all-inclusive pieties.

Artist-photographers began to stage themselves as outsiders, and the most notable of these was the Swiss Robert Frank, author of *The Americans* (1959), the record of a journey through the poorly lit margins of the USA From this time onwards, however, photography's own inventory of *images gratuites* began to be supplemented by a series of news events too radical to be contained by convention. These too can be listed. (1) The A-bomb, introduced in 1945, made regular appearances thereafter, although always ambiguously, for it seemed to be both a weapon devised by man and at the same time a part of nature's own systems. It also acted both in a split second and slowly over extended time, like a weather front. (2) Space too entered the pictorial economy in the 1960s, redefining 'man', especially Russian man, as embryo or as a clumsy being taking first steps in an alien environment. These first steps, imperfectly foreseen, appeared shakily screened on available (television) technology, and broke the code of transparency to which photographic imaging had been committed since the 1930s at least. (3) *Actes gratuites*, the assassinations of American notables in particular, promoted the fear that society might decay from within and unpredictably. These acts, often taken by casual and amateur cameramen, associated high drama with low resolution, and further undermined the ideal of transparency. (4) The Vietnam War, entered into almost inadvertently by the USA in the mid-1960s, was always out of control, in part because one of the freedoms at issue was precisely freedom of access. Vietnam, one of photography's most vivacious enterprises, completely disrupted the benign model of human conduct wished for in the 1950s. (5) Research carried out into Earth Resources in the 1960s and after, and then into the recesses of Space, familiarized audiences with digitized imagery which, although vouched for by science, lacked the kind of guarantees of realism carried by photography in the Age of Transparency. Practical and everyday life, which had traditionally been photography's domain, began to lose its cachet in the face of the many kinds of incredible otherness put on display by the post-modern media.

Actualities in 1839

Photography was announced in 1839, and this made it a post-romantic medium. The romantic era came to an end in the 1830s, in 1837 to be exact, according to *The Oxford Book of English Verse of the Romantic Period* (1935). Eras, with their turns of mind, are difficult to define, but the romanticism of Keats and Shelley presents the poet as a suitor and often as a victim in relation to an unbearably beautiful Nature. The relationship is disproportionate, for Nature is in league with Time, and with its associate Death. The contemporary social world scarcely features in any of this, because when seen in the context of Time it is little more than a transient blot on the landscape: Shelley's *Adonais*, published in 1821, contains the line 'Heaven's light forever shines, Earth's shadows fly'. In the 1830s, however, there was a change of mood, announced most clearly in Tennyson's *The Lady of Shalott*, which first appeared in his *Poems* of 1833. Tennyson might almost have intended a diagnosis of photography in this poem, for it lists the kinds of passing traffic with which the medium would always be concerned. But, with respect to 1839 and the pioneering years, the real importance of *The Lady of Shalott* lies in its equivocations. The eponymous heroine, secluded in a tower, looks at the world only through a mirror which allows her to weave an account of the everyday world passing on the riverbank beneath her window. Often tempted to look reality in the face, she eventually succumbs to the image of Sir Launcelot, an epitome of the carnal and the courtly. She dies almost immediately, of what can only be described as some kind of malady of the quotidian, but not before she has arranged herself in a boat which will take her corpse downriver and amongst the citizens who have been the subject of her art. The everyday, that is to say, constitutes a fatal attraction, as well it might considering the contempt in which it had been held by the likes of Keats and Shelley. In fact Tennyson gives such a charming account of the commonplace that the Lady's lapse seems quite excusable. This was the ambiguous milieu that photography entered in 1839.

Fox Talbot and Art's Intentions

Photography's history appears to have begun quietly enough in 1839. Neither Louis Jacques Mandé Daguerre nor William Henry Fox Talbot meant to revolutionize the visual arts. Yet it can be claimed, and with some justification, that that is exactly what they did. The claim, however, can only be made at a psychic level, with photography regarded as a symptom. Neither Daguerre's silvered daguerreotypes nor Talbot's calotypes (from the Greek word, *kalos*, meaning beautiful) look like the stuff of which revolutions are made – even in the world of the visual arts. Nevertheless they have to be given a share of the credit or blame whenever modernism is considered. Modernism, when thought of within the longer reaches of intellectual history, seems to have originated with the Enlightenment, in the late

Calotype

Also know as Talbotype. Paper with as little obvious grain as possible was brushed over with a solution of iodide of silver in iodide of potassium, washed in distilled water and dried. It could be kept in storage until required to be used when it was moistened with a solution of gallo-nitrate of silver and exposed wet. An exposure of six minutes was required for a landscape. The negative was then washed and fixed in hypo (sodium hyposulphate). Wax or oil rendered it more translucent for printing.

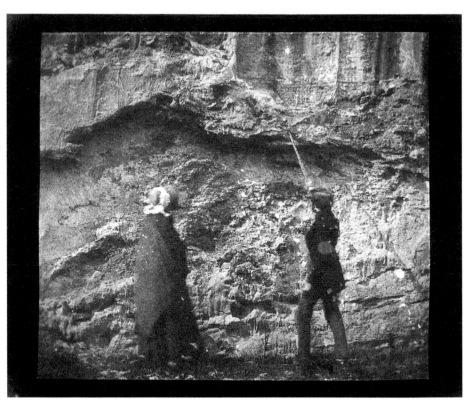

William Henry Fox Talbot
The Geologists, c. 1844.
Calotype. 152mm × 203mm
(from the Collection of the
National Museum of Photography,
Film & Television)

Salted-paper print

Calotype negatives were
reproduced as salted-paper prints.
Paper was soaked with non-
light-sensitive silver salts, and
sensitized with silver nitrate just
before use. Arrowroot was
sometimes applied to the paper
to stop the silver salts penetrating
too deeply. The silver particles on
the surface of such prints were
subject to damage, by atmos-
pheric pollution and from moisture.

eighteenth century, and to have developed darker and darker aspects as the nine-
teenth progressed. Formerly, or before the Enlightenment, artists knew exactly
what they were supposed to do; afterwards this certainty evaporated. This is how
the philosopher Karl Jaspers described the situation of the modern artist, writing
in 1933: 'The world gives him no definite commission, and he must, at his own risk,
commission himself. He can be certain of no clear response, or at best of a response
that is false, he has no clearly defined rival or antagonist and so he ends by becoming
equivocal even to himself.' Jaspers' was a pessimistic diagnosis, but he could have
been describing the position of photography from the very beginning. The medium
might almost have been invented to underline the uncertainties described by Jaspers.

In 1839 painters, sculptors and graphic artists still knew more or less what was
expected of them. It was only an exceptional artist, such as Delacroix, Géricault
or Goya, who ventured far into the unknown. Photographers certainly didn't think
of themselves as radicals touching on deep and troublesome issues of the moment,
yet their medium raised the problem of what Jaspers called 'commission' as never
before. Photographs, especially those taken in the early 1840s, were meant as
demonstrations of the powers of the new medium. They are often of available
items: a table top, rooftops, a haystack, ceramics on shelves, a display of hats in a
milliner's window, a gateway, some trees, a door, a window, all of these things are
featured in anthologies of early photographs. Historians have tended to treat

18

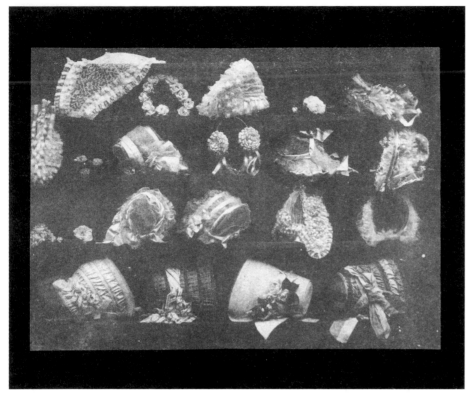

William Henry Fox Talbot
The Milliner's Shop, c. 1844.
Calotype. 142mm × 193mm
(from the Collection of the
National Museum of Photography,
Film & Television)

these early pictures as samples, worth illustrating but not worth puzzling over. They amount, that is to say, to a novel kind of gratuitous art authored virtually at random. This would be all very well, if we were prepared to accept such an art as a possibility, but this seems something we have difficulty in crediting. If a picture of a haystack, for instance, was taken in 1844 there must surely have been a reason, no matter how subliminal?

Early photography raises the question of 'commission' or of intention very acutely. How can we discover what the picture meant? Perhaps by considering it in conjunction with other samples by the same author, or from the same moment, in the hope of discovering a common factor. Detective work of that kind, although possible, is difficult because photography was, and remains, protean and any sense of a meaning can only be provisional. What remains is an impression that the picture ought to signify, but in the absence of a certificated meaning there can only be surmise. We supply a meaning or a reading where we imagine that one ought to exist, and this has always made of photography a collaborative work, constantly in formation – in a way which is unthinkable with respect to painting and the conventional arts. Jaspers, writing in 1933, judged that the lack of a 'definite commission' isolated and confused the artist, but it would be just as plausible to assert, in photography's case, that it had the effect of implicating the public and posterity – or at least those elements in it committed to the idea of meaning.

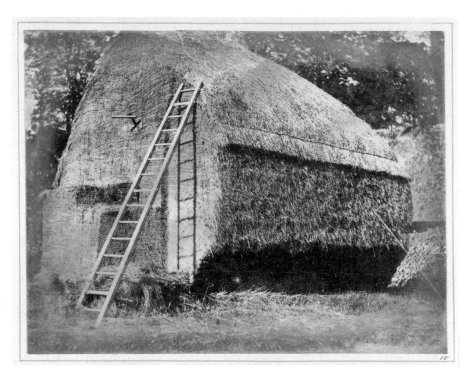

William Henry Fox Talbot
The Haystack, c. 1844.
Calotype. 165mm × 216mm
(from the Collection of the
National Museum of Photography,
Film & Television)

Talbot, the inventor of the negative-positive process, exemplifies the problem of what Jaspers referred to as 'commission' and 'equivocation'. *The Haystack*, one of his best-known pictures, has been frequently reproduced, and it appears in Talbot's own book of 1844–6, *The Pencil of Nature*, cited as a demonstration of photography's capacity to disclose 'a multitude of minute details which add to the truths and reality of the representation, but which no artist would take the trouble to copy faithfully from nature.' It may have been intended as no more than a documentary study. Farmyards, until the mechanisation of agriculture in the 1940s, were showgrounds for country crafts, thatching and carpentry in particular, and Talbot may simply have been interested in the skills of the artisans who worked on his farm at Lacock Abbey. There are other pictures in his oeuvre, hardly ever reproduced, of the man who built the stack. On the other hand it could also be read as an emblem of the seasons, for it is a work of springtime and of early summer consumed during the autumn and the winter.

A much more compelling account of *The Haystack* is given by Mike Weaver in his book of 1986, *The Photographic Art*. He notes that Talbot was a scientist and scholar of the greatest distinction, and someone who could not possibly have overlooked the religious and symbolic significance of the haystack. No one at that time and in Talbot's position, he suggests, could have ignored the works of the preacher in Isaiah 40:6–8 to the effect that 'All flesh is grass... but the word of our God shall stand for ever.' All the more so as the scene also features a ladder, which in its turn must have invoked Jacob's dream in Genesis 28:12 with its

20

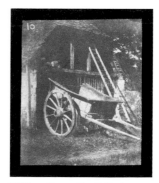

William Henry Fox Talbot
The Ladder, c. 1844.
Calotype. 173mm × 184mm
(from the Collection of the
National Museum of Photography,
Film & Television)

William Henry Fox Talbot
Cart outside a barn, c. 1844.
Calotype. 216mm × 96mm
(from the Collection of the
National Museum of Photography,
Film & Television)

implications of transcendence and escape from the dross of contingency (or 'Earth's shadows', in Shelley's terms). But if this was part of his programme, why didn't he say so? Because it was unthinkable at the time to subject a work of photography to such a burden of meaning.

Weaver supports his reading of the pictures by drawing on Talbot's *English Etymologies*, published in 1847. His suggestion is that the theoretical writing in that book amounts to what would later be called an artist's statement. Talbot's vision, as expressed in the *English Etymologies*, was of an originating moment in which primal things, the sun in particular, gave rise to complex ideas. This is how he describes the Sun: '*Orbis* in Latin signifies anything round; it embraces both the ideas of the Sun's disk (and consequently the Sun itself), and that of a *wheel*. It is therefore not impossible that the different etyms of *Yule* may be ultimately found to flow together into one notion of the *Sun wheeling round*.' Weaver makes much of Talbot's discussion of the sun, because photographs were in effect sun pictures. He quotes again and at length another notion from *English Etymologies* that there are words which have 'TWO *distinct origins*, which they have coalesced together in course of time, because they represent ideas capable of union. There are many such in modern languages, and they are a most useful and valuable class of words. No wonder, since they contain in themselves, and express with a nervous brevity, the essence of more than one primitive idea.' The word in question here was *hardy*, which Talbot thought of as an amalgam of *heart* and *hard*. Talbot's vision, it seems, was one in which language not only contained traces of the original

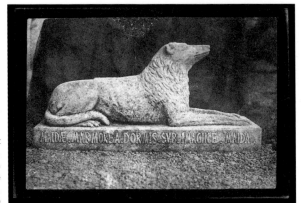

things on which it had been founded (he actually saw a congruence between *thing* and *think*) but also preserved within itself a nostalgia for the originating moment when words still meshed with words and with their founding objects. If Talbot thought along these lines he could scarcely have envisaged his photographs as mere samples and demonstrations of the practical power of the medium.

Talbot's concept, as expressed in *English Etymologies*, was marked by a feeling for continuity. There was an originating moment, or coming to consciousness in the presence of the sun. Thereafter language and consciousness evolved, slowly drawing away from that primal moment when things were thought. Talbot even imagined himself as re-enacting the movement of culture and language in his own work. Weaver quotes him twice on etymology, as the activity of 'one who follows Ariadne's clue through a tortuous labyrinth' (with reference to Theseus who slew the Minotaur in Crete and then had to escape from the Labyrinth, following the thread provided by Ariadne) and again as Diogenes, founder of the Cynic sect, who sought an honest man at midday with the aid of a lantern: 'The etymologist is like a man exploring a dark cavern with the aid of a farthing rushlight; he sees well enough what is near, but there always remains an unfathomable depth of darkness beyond.' Unsupported by the sense that labour should be painstaking and gradual neither Talbot nor Daguerre would ever have concluded their researches. It was the same concept, vastly expanded, which underlay and shaped Darwin's theory of evolution, in which the present was envisaged as the outcome of an infinitude of fine adjustments carried out over the ages.

If continuity is a determining motif in Talbot's aesthetic it helps to explain other pictures often quoted but never analyzed. He took a number of photographs in the environs of the Abbey which look like traditional conversation pieces using family and servants. One is of a transaction on the lawn of the house with countrymen selling fruit and vegetables, and another shows afternoon tea being taken out of doors. In a conversation piece of the eighteenth century there would have been far less attention to transactions of the kind which Talbot stages. He seems to have been interested in establishing a social connection between the upper caste

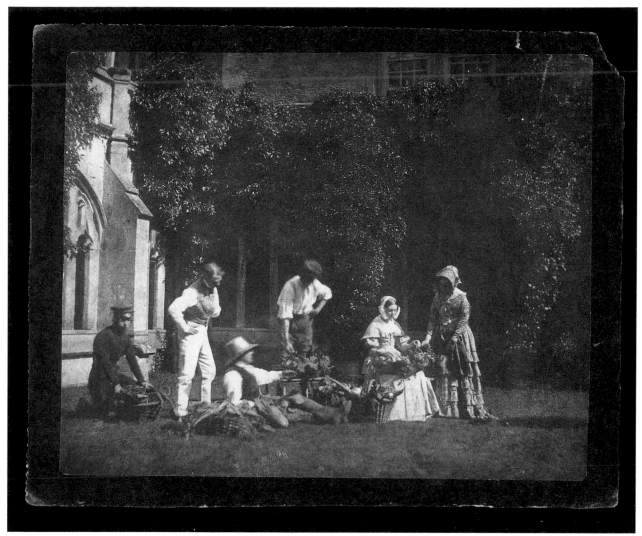

William Henry Fox Talbot
The Fruit Sellers, c. 1844.
Calotype. 160mm × 210mm
(from the Collection of the
National Museum of
Photography, Film & Television)

people of the house and working people as representatives of the countryside beyond. It is clear from their dress, and from their elaborate bonnets in particular, that the women in this world are indoor creatures, just as much as the tanned servants, lumpishly got up in improvised uniforms, belong to the outdoors, to that community of gamekeepers and carpenters portrayed in other pictures. The man of the house, on the other hand, seems to mediate between these representatives of the indoors and the outdoors. The gentlemen, distinguished by their flamboyant stove-pipe hats, sometimes put aside or doffed in the presence of ladies, appear to belong to both domains, somewhat apart from both, but fitted to participate in either. All this is to suggest that Talbot's is a transactive vision of a society constituted of relationships between its different elements. No thing or person is to be identified and understood in its own right but only in conjunction with

46. Baia (gone) (5 et 6)

24

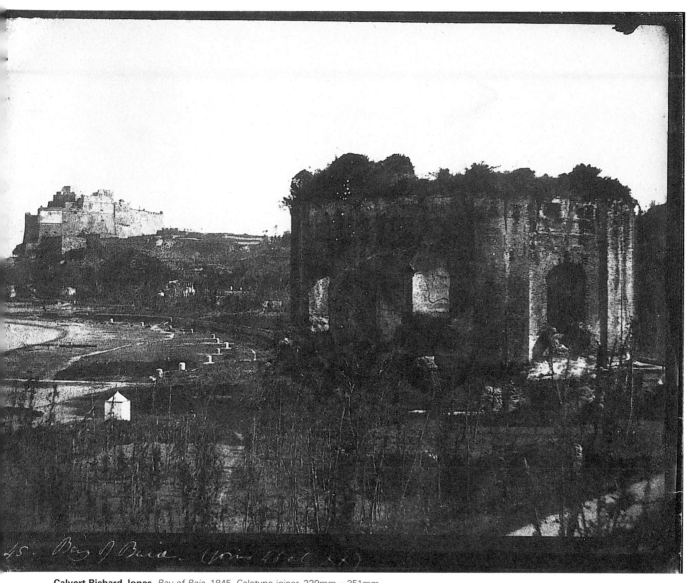

Calvert Richard Jones. *Bay of Baia*, 1845. Calotype joiner. 229mm × 351mm
(from the Collection of the National Museum of Photography, Film & Television)

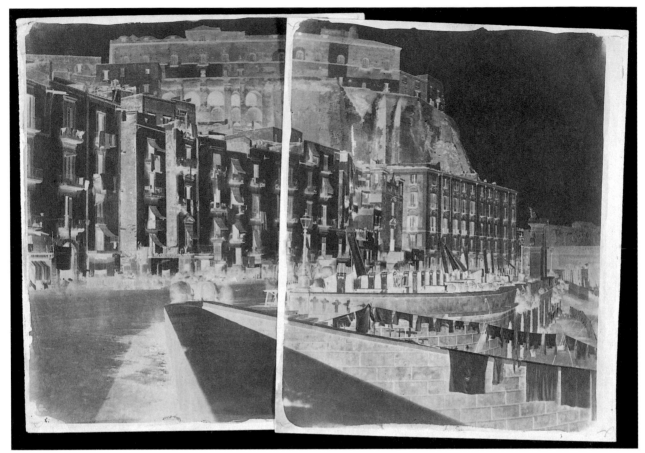

Calvert Richard Jones
*St. Lucia, Naples, c.*1845.
Calotype negatives (joiner).
228mm × 178mm each
(from the Collection of the
National Museum of
Photography, Film & Television)

surroundings widely extended: a gentleman, such as Talbot, with respect to a lady and to the farmhands and craftsmen who made up Lacock Abbey and society at large. To go further and to say that this was ever Talbot's selfconsciously held intention would be to go far beyond the evidence available. What is on offer here, that is to say, is the kind of retrospective account of 'commission' which photography has always invited.

Calvert Richard Jones: 'Joiners' and Places Apart

Talbot was what would later be called an avant-garde artist, working for the most part amongst dilettantes. One of these was Calvert Richard Jones, a close friend of Talbot's cousin, Christopher Talbot. Jones and Christopher Talbot met whilst students at Oxford during the 1820s. Christopher was wealthy. He owned yachts and liked to tour the Mediterranean purchasing works of art. He was often accompanied by Jones, an ordained but inactive priest. In 1841 Jones took up

calotype photography, but for years he had very little success, mainly because of difficulties with paper quality. His luck turned, however, in 1845 when he was on a final trip to the Mediterranean, focusing on Naples and Malta. He became interested in panoramic photography, achieved by what he called 'joiners', which were attached or overlapping images of land-, sea- and townscapes. Although these 'joiners' scarcely feature in histories of the medium, it seems that they represent a break with the aesthetic of Talbot himself, who had been preoccupied by specific objects, by individuals and by identifiable buildings. The 'joiners', on the other hand, register, and for the first time in photography, the otherness of places. Naples 'joined', for instance, looks like an environment going about its own business, characterized by lines of washing hung out to dry and by oblivious citizens deep in conversation. Jones' acknowledgement of the distinctness of other places and their resistance to appropriation by the photographer had no immediate sequel. It was only with the coming of what was called the 'New Topography' in the 1970s that this idea of the autonomous or self-possessed environment would re-emerge, although in the 1970s and after it was coloured by evidence of environmental damage.

Daguerreotypes: private experience

Early photographs taken from salted-paper negatives, of the kind which gave so much trouble to Calvert Jones, seem makeshift and approximate, at least when compared with anything which follows. They look, in fact, like proto-Cubist art, or as though they belong to some Modernist experimental phase of the 1920s, for their subjects have to be re-constructed, pieced together from very schematically laid-down highlights and shadows. Daguerreotypes, which also belong to this early phase, make altogether different demands on audiences. It is as if they have their own weather systems, for their metallic surfaces catch the light, obscuring and dissolving the image within. Daguerreotypes are to a high degree illusory, and very much in the style of the dioramas for which Daguerre was also well known in the 1830s. The Paris diorama, developed by Daguerre, placed the spectator in a small amphitheatre in front of translucent painted screens subject to changing light. A performance might start at dawn and end at dusk and feature landscape, trees, mountains, villages and their inhabitants, bivouacking soldiers, a blacksmith's shop and a harbour scene. But it was the illusion and the miracle of changing light which mattered, bringing the whole to life and captivating audiences. Daguerreotypes replicated the experience of the diorama in miniature, for they had to be manipulated for the sake of a clarity which was only ever achieved in part. Daguerreotypes emphasized the presence of the viewer, the experience of looking as a physical encounter, privately carried out. This was also true, up to a point, of calotypes which had to be scrutinized and carefully read; and it was certainly true of stereocards (introduced in the 1850s), for they had to be placed in viewers and manoeuvred into position.

New Topography

A lot of landscape photography published from the 1970s onwards, in both Europe and the USA, can be termed New Topography. The title was invented in 1975 by William Jenkins, organizer of the exhibition 'New Topography: Photographs of a Man-Altered Landscape' at George Eastman House in Rochester, New York. American New Topographers include Robert Adams, Lewis Baltz and Joe Deal. In Europe the tendency is represented by Gabriel Basilico and Werner Hannapel. It was, and remains, a very objective style, using panoramic and landscape formats. Their subject has always been human settlement, often in an inorganic relationship with nature.

Daguerreotype

Details of the process were published in September 1839. Daguerreotypes were unique images. When seen from a dark background they appear as positives, and when seen with the light behind one as negatives. The basis is a highly polished silvered copper plate, sensitized with fumes of iodine, with the latent image developed in fumes of mercury. At first exposure times were very long, between three and 30 minutes, but the process was so improved that portraits could eventually be taken in a matter of a few seconds. Easily abraded, daguerreotypes were protected by glass and preserved in cases.

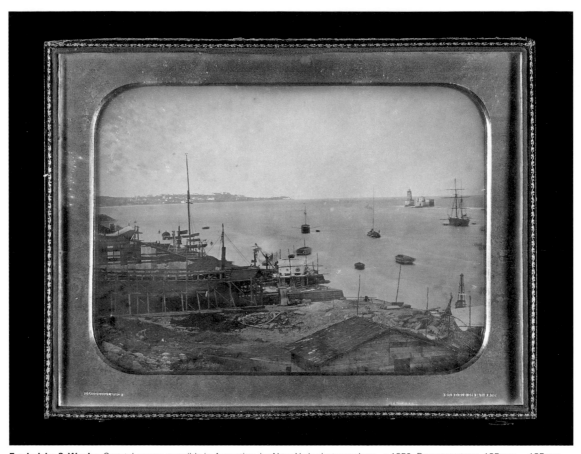

Fredericks & Weeks. Coastal scene, possibly in Argentina, by New York photographers, *c.*1850. Daguerreotype. 135mm × 185mm (from the Collection of the National Museum of Photography, Film & Television)

Sublime spaces: waxed paper and albumen

There were major changes in photography during the 1850s. Although Talbot's negative-positive process had made it possible to produce limitless copies from a single negative, technical limitations, such as the poor paper quality which dogged Calvert Jones, meant that this remained no more than a possibility. And daguerreotypes, although they gave a wonderfully polished account of appearances, couldn't be replicated by any photographic printing process. Talbot made matters worse by trying to assert patent rights over his invention, until he was asked to desist in 1852 by such notables in the Royal Society as the astronomer the Earl of Rosse. Innovation, stymied in Britain, was taken over by the French, most notably by Gustave Le Gray, a painter who invented the waxed-paper process. He applied rice water, sugar of milk, iodide of potassium, fluoride of potassium, white honey and egg white to waxed paper, which was then sensitized to light with an acid solution of nitrate of silver and developed with gallic acid, Histories of photography

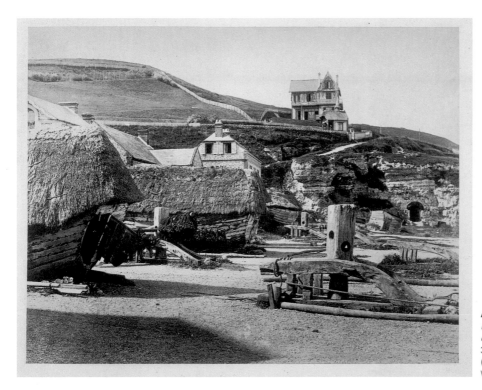

Alphonse Davanne
Etretat, Les Caloges,
c. 1860. Albumen paper print.
342mm × 433mm
(Michael and Jane Wilson,
Wilson Centre for Photography)

abound with recipes of this kind, useful reminders of the degree to which photography was mixed up not just with chemistry but with home economics and regional produce. Nicéphore Niépce, for example, who was the inventor of a direct positive process in the 1820s, and who deserves credit as the ultimate inventor of the medium, worked with a base of bitumen of Judaea, which was a kind of asphalt, and with oil of lavender. Photography tasted and smelled of Nature, of eggs, honey and lavender, and could almost be thought of as a discovery as well as an invention, as Nature's own way of registering its appearances. The advantage of Le Gray's waxed-paper process was that it allowed negatives to be prepared up to two weeks before use and then developed several days after exposure. Previously they had had to be prepared on the day before use and then developed immediately after exposure. As a result photographers could travel more easily, which was an advantage for Le Gray who worked for the Committee of Historic Monuments in France, taking pictures of outlying antiquities. Waxing also produced sharper images, as did the albumen printing techniques which were introduced at the same time. Albumen prints were made on paper which had been treated with a mixture of salt and egg-white and allowed to dry before being sensitized with silver nitrate. In the salted-paper prints (calotypes) of the 1840s the image lay within the paper, like a shadow; in the new albumen prints of the 1850s, taken from waxed-paper negatives, it lay instead within a transparent surface layer carried above the paper backing.

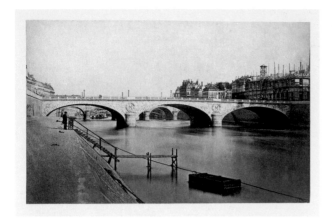

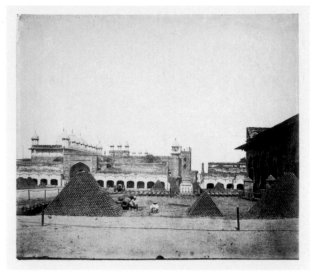

left:
A. Collard
Bridge In Paris, France, c. 1855.
Albumen paper print.
267mm × 416mm
(Michael and Jane Wilson,
Wilson Centre for Photography).

right:
Dr John Murray
*Arsenal and Pearl Mosque,
Agra, India,* 1857.
Albumen paper print.
382mm × 441mm
(Michael and Jane Wilson,
Wilson Centre for Photography)

The photography of the 1850s is probably the most desirable ever taken, and forms the backbone of most major collections. Much of it was printed in France by the firm of Louis Désiré Blancquart-Evrard, a businessman and chemist from Lille. Blanquart-Evrard had begun to experiment with photographic printing on paper in 1844 (just when his French contemporaries were preoccupied by the daguerreotype), and in 1851 went into business as a printer in Loos-lès-Lille. This was also the year in which another major printing house was established in Paris: H. de Fonteny's Imprimerie Photographique. Blanquart-Evrard made the plates for Maxime du Camp's *Egypte, Nubie, Palestine et Syrie* (1852), for John Beasley Greene's *Le Nil* (1854) and for Auguste Salzmann's *Jerusalem* (1856). At the Imprimerie Photographique, de Fonteny made the prints for Charles Nègre's *Le Midi de la France, sites et monuments historiques photographiés* (1854–5) and for Felix Teynard's magnificent *Egypte et Nubie* (1858). These are no more than individual instances from a prolific era in photographic publishing. It is tempting to imagine that these grandiose pictures of the 1850s were intended to be seen as works of art, or at least to be put on view in the public domain; but they, like the calotypes of the 1840s, were really meant for private enjoyment, destined to be kept in albums in libraries. Relatively few of these volumes were ever printed, and many have been subsequently broken up and distributed as prints.

What must be stressed is that these new French paper prints were taken and made according to new aesthetic premises. Whereas Fox Talbot and Calvert Jones had represented space with its objects as something constructed which had to be analyzed, the new photographers of the 1850s thought of their art as more thoroughly representational. The ghostly world of the salt print was replaced by a much richer environment, one in which even shadows gave the impression of being tangible. These new photographers were Realists, somewhat in the style of

Eugène Cuvelier
Le Bornage de Bas Breau, France,
c. 1860. Albumen paper print.
342mm × 253mm
(Michael and Jane Wilson,
Wilson Centre for Photography)

Pierre Emonds
Cour de Rohan, Paris, France,
c. 1872. Albumen paper print.
267mm × 215mm
(Michael and Jane Wilson,
Wilson Centre for Photography)

their contemporary Gustave Courbet, whose subsequently famous *Burial at Ornans* was shown in the Paris Salon of 1850–1. Realism tried to express physical experience, to make it possible for an onlooker to imagine just what it might be like to work manually, breaking stones on the edge of a road or gleaning corn. It was less a matter of representing a worker as a typical figure in a typical setting than of pointing to those moments of concentration of which work is made up. Courbet was a countryman who came to town in the 1840s and was well aware that metropolitan culture separated people from first-hand experience of raw materials. The city's way of thinking was, by contrast, instrumental and abstract.

Photography in the 1850s was in no position to match painting. Its descriptive powers were limited and exposure times too long to register action. Photographers had to work within the limits of their medium and to compensate for its shortcomings. Waxed-paper negatives, in conjunction with the recently introduced process of albumen printing, made it possible to render surfaces far more accurately than ever before. Objects could be replicated, almost to perfection; but that degree of truth to appearance has always been held in contempt in art, because it makes so few claims on the mind. The new paper processes of the 1850s were saved for art almost by virtue of their inadequacies. It remained difficult to correlate lighted and shaded areas in a scene, and skies were almost impossible to take, which meant that they had to be photographed separately and printing carried out from two negatives. Shadows within the landscape remained a difficulty, for if lighted surfaces were to be shown there was no time to realize what lay in shade. Photography, however, put this deficiency to use, for the configuration of opaque areas within the space represented could only be inferred, especially from outlines

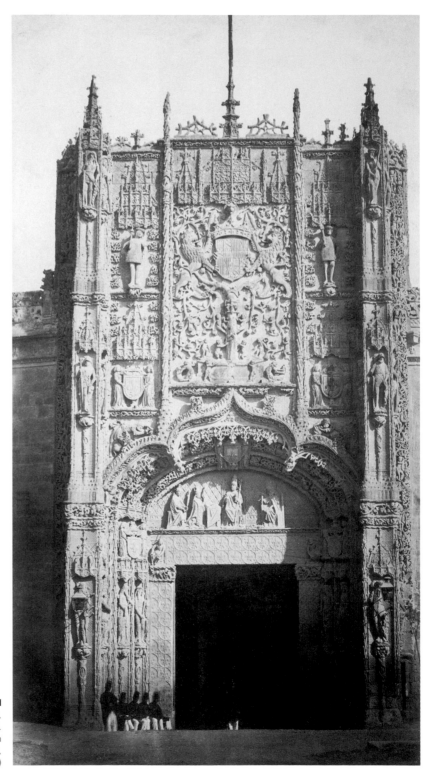

Charles Clifford
Colegio S. Gregorio-Valladolid, Spain,
*c.*1850. Albumen paper print.
430mm × 234mm
(Michael and Jane Wilson,
Wilson Centre for Photography)

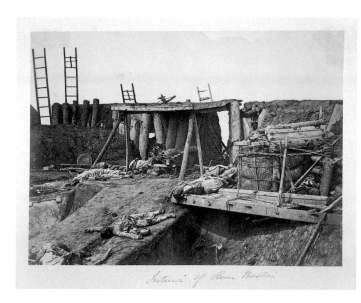

Felice Beato
Interior of the River Bastion Taku Fort, China, c.1860. Albumen print. 224mm × 300mm (Michael and Jane Wilson, Wilson Centre for Photography)

and cast shadows, and this meant that the mind had been put to work – and the pictures saved from charges of mere Naturalism.

Photographs of the 1850s have to be worked out, and this was especially true of the many architectural studies made during this period. Facades in pale stone were subject to passages of profound shadow, and the problem of legibility was often compounded by the fact that photographs of buildings were almost always of just part of the structure: a doorway, or a set of windows, or a passage of stonework. It was also hard to give details of the ground plan of a cathedral, for instance, when making pictures of its west front, which meant again that the idea of the building had to be inferred from extracts – as is the case in Charles Clifford's imposing pictures of Spanish architecture. What all this activity of calculation and inference meant was that a typical albumen print of the 1850s became a work site, crowded with diverse kinds of evidence, which had to be scrutinized into shape. It is this element of pleasurable labour which connects the photography of the 1850s with the art of Realism. The difference is that whereas Courbet paints the stonebreaker and his acts of attention, the photographers of the era try to envisage the material world as if through the operative's eyes. In this context it is worth pointing to Felice Beato's pictures of the Taku Fort, captured from the Chinese by British and French expeditionary forces in 1860. Beato, a Venetian, accompanied the Western armies and took the first pictures of China. These photographs are usually presented as providing interesting details of colonial war, but they are just as engrossing as evidence of handicraft, for they give information on the building and furnishing of the fort and on the manufacture of Chinese armaments, bound with rope and mounted on wood. The victory may have been to the expeditionary force, but what survives is an inventory of Chinese ways of making and assembling – all very much in the Realist spirit.

Ludwig Angerer
Bukarest, 1856, Romania. Salted-paper print. 208mm × 268mm (Michael and Jane Wilson, Wilson Centre for Photography)

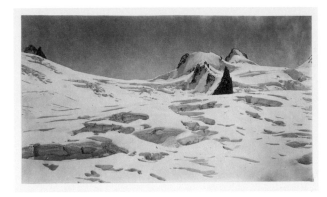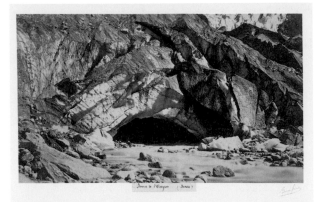

left:
Bisson Frères
Alpine Study, France, *c.* 1860.
Albumen paper print.
222mm × 385mm
(Michael and Jane Wilson,
Wilson Centre for Photography)

right:
Bisson Frères
Source de l'Oueyron (Savoie),
French Alps, *c.* 1861.
Albumen paper print.
230mm × 388mm
(Michael and Jane Wilson,
Wilson Centre for Photography)

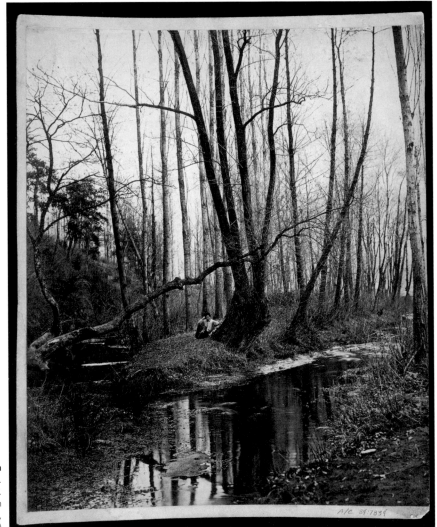

Anon
Man Beside River, France, *c.* 1865.
Albumen paper print.
385mm × 320mm
(Michael and Jane Wilson,
Wilson Centre for Photography)

34

Photomicrography

Historians have devised a canon, which usually opens with Nicéphore Niépce's first picture of rooftops at Le Gras, 1827. This is followed by Fox Talbot's first picture, of a latticed window at Lacock Abbey, taken in August 1835. Thereafter a daguerreotype, usually of the Boulevard du Temple, photographed in Paris in 1839–9. Thence to *The Haystack* of 1844 and outdoor portraits in calotype taken by the Scottish artists David Octavius Hill and Robert Adamson in 1844–5. This orthodox history of the medium presents it as a diminished version of painting history, and one with its own body of masterworks. It is a history which underplays the heterogeneity of the medium and its many parallel strands. Photomicrography is one of these strands, and seems to have been part of photography from the very beginning. The term refers to the taking of pictures through microscopes. Sir David Brewster dedicated his *Treatise on the Microscope* (1837) to Fox Talbot; and on the announcement of Fox Talbot's negative-positive process by Michael Faraday at the Royal Institution on 25 January 1839, various examples of the new art were put on show. Among these were enlarged images of wood shavings, showing the pores, and an insect's wings, showing the reticulations. Glass negatives and the collodion process, introduced late in the 1840s, increased the clarity of photomicrographs. Collodion was named after the Greek word for glue (*kollos*), and it was made from guncotton, a kind of explosive, dissolved in ether, a nice instance of the often lurid technical history of photography. Photomicrography was constantly being improved, but it had something of a pictorial heyday in the 1850s and 1860s, when it was associated with such names as those of Alphonse de Brébisson, a botanist who specialized in microscopic algae, and of Albert Moitessier, author of the relatively well-known *La Photographie appliquée aux recherches micrographiques* (1866). One page of illustrations in Moitessier's book features six slides: starch grains, capillaries in pine wood, crystals of uric acid (an element found in small quantities in the urine of men and quadrupeds, and as the chief constituent in that of birds and reptiles), diatoms (microscopic unicellular Algae found especially at the bottom of the sea and making up fossil deposits), blood corpuscles, and the scabies louse (*acarus de la gale* in the French original). Moitessier's plate is used in Michel Frizot's *Nouvelle Histoire de la Photographie* (p. 227, Paris 1994) to illustrate photomicrography in its golden age. Typically, Moitessier's subjects are drawn from corporeal fundamentals, with respect to bodily heat, metabolism and sensation. The invitation, as in so many photomicrographs of the era, is to imagine what might be involved in digesting food or attending to an itch. Human fleas often appear in collections of the 1850s. Adolphe Bertsch's pictures, illustrated here, are from the 1850s, and by a pioneer in the field, a typical photography inventor. In 1852 Bertsch introduced a mechanical shutter made of a revolving metal disc with an opening, set by a spiral spring; and in 1860 he announced a miniature portable camera and a 'megascope' enlarger. His photomicrographs

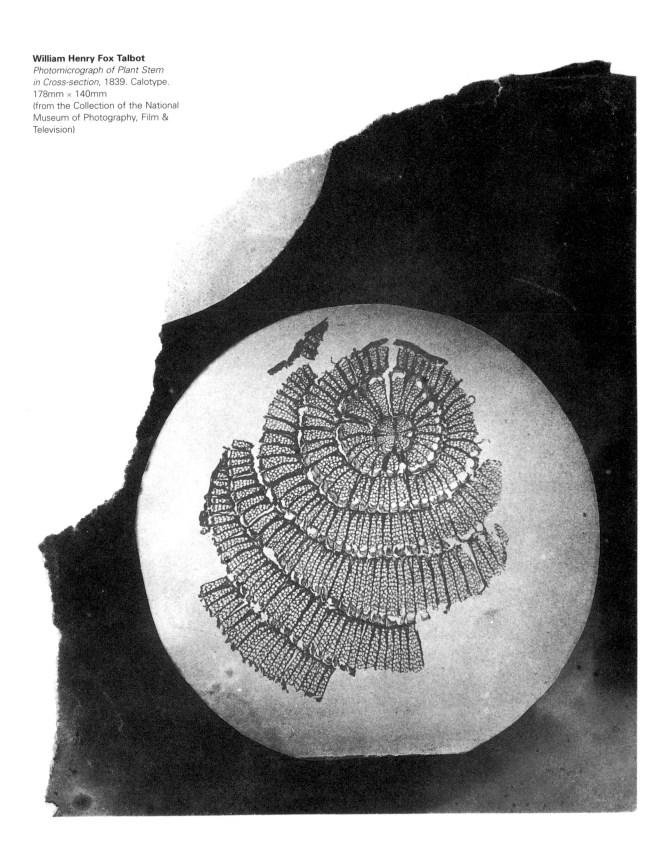

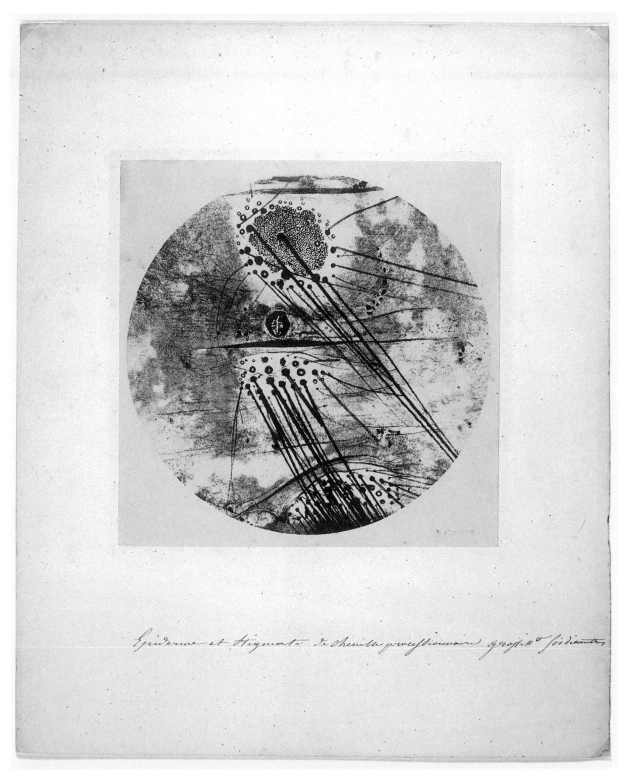

Adolphe Bertsch. *Skin and Spiracle of Processionary Caterpillar × 500*. Photomicrograph, late 1850s. Albumen print. 304mm × 254mm
(from the Collection of the National Museum of Photography, Film & Television)

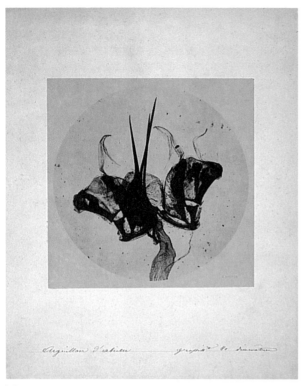

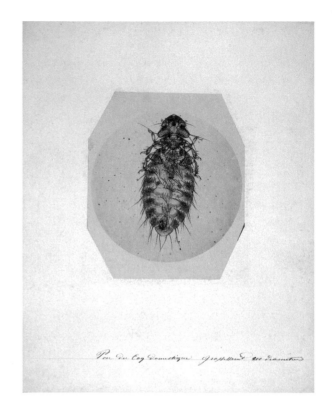

left:
Adolphe Bertsch
Bee's Sting × 80.
Photomicrograph, late 1850s.
Albumen print. 303mm × 255mm
(from the Collection of the
National Museum of Photography,
Film & Television)

right:
Adolphe Bertsch
*Louse from Domestic
Cockerel × 200.*
Photomicrograph, c.1853.
Albumen print. 305mm × 254mm
(from the Collection of the
National Museum of Photography,
Film & Television)

were published in the late 1850s in the *Bulletin de la Société française de photographie*, and from 1853 in *La Lumière*, a photographically illustrated periodical. The pictures, while ostensibly of scientific interest, invoke human sensations, sometimes excruciatingly: the sting of a bee, the mouth of a wasp, a human flea, a processionary caterpillar.

The photomicrographers, with their interest in pricking and stinging and sucking, were Realists, akin to Courbet with his remarks on stone-breaking and grain-sifting. The entire microscopic world can be related to mankind, subject to predatory bees and wasps and fleas. Mankind exists at the top of the sensory chain, but the photomicrographers were interested in demonstrating just how far the chain stretched into invisibility by probing the lives of microbes and diatoms. What photomicrography demonstrates in these display panels of the 1850s and 1860s is a continuity from that scarcely imaginable other world into the human ambit, as well as the kind of bodiliness which might be responsive to the sting of a bee. Whereas painted Realism stretched only to rocks and grains of corn, the photomicrographers had access to remote outer limits. Many of the hidden details and structures they revealed looked surprisingly tangible, like the work of a constructor-deity. Photomicrography filled in the gaps, in a way which was compatible with Darwin's new gradualist theory of evolution.

The Stereo Revolution

If photomicrography filled the gaps vertically, from bacteria and parasites upwards into the human domain, the horizontal continuum was taken care of by stereophotography. Stereo, in which near-identical paired images are viewed through two lenses, is as old as the medium itself; although it only began to go public in the 1850s. By 1860 it was in possession of the field, at least in commercial terms. To judge from histories of photography, stereo seems to have been statistically impressive and aesthetically inconsequential. If it was as popular as it was said to be (so the argument runs) it can't have amounted to much aesthetically; and certainly many stereocards, when seen without the aid of viewers, look bland enough. 'By 1858,' Helmut and Alison Gernsheim remark in *The History of Photography*, their encyclopaedic catalogue of inventions published in 1955, 'the London Stereoscopic Company were advertising a stock of 100,000 different photographs of famous buildings and places of interest in England and abroad, had sent their staff photographers as far afield as the Middle East and America.' Stereo was dedicated to making the world known in all its variety. The London Stereoscopic Company had been founded in 1854 by George Swan Nottage, introduced by the Gernsheims as 'a man of humble origins', but who later became Lord Mayor of London. The history of stereo is a history of commercial success stories, especially those of the American firms Underwood & Underwood, the Keystone View Company and H. C. White & Co, all active in the 1890s and after. By 1901, for instance, Underwood & Underwood were manufacturing 23,000 stereocards per day, as well as 300,000 stereoscopes annually. One consequence of the stereo revolution was that the world could be grasped as an infinity of phenomena, as a vast collection of things and views. Stereo gave rise to an understanding of the world, with all its geology, plant life and architecture, as being susceptible to pragmatics and to management. This dire prospect was undermined in the 1890s by the discovery of X-ray photography. By giving shape to the idea of underlying forces, X-rays implied that all those distracting items in the 'real' world could be re-classified as epiphenomena.

Despite its popularity, stereo photography has every right to non-statistical consideration in the aesthetics of the medium. In particular, it harboured several new genres, which it introduced, exploited and exhausted, each one within a matter of a few years. This rapid process also explains its low standing, for that sort of trajectory belongs to entertainment and the mass market with its crazes and taste for novelties. Street photography was one of the first of these stereo genres; and it flourished around 1860. Everyone of note in stereo also took what were then called instantaneous pictures in the streets of the metropolis: William England in London, George Washington Wilson in London and Edinburgh, Adolphe Braun in Paris and Edward Anthony in New York. England was Nottage's leading photographer; Wilson had a studio in Aberdeen and had specialized in landscape;

Stereo photography

From the Greek *stereos* meaning solid. Stereo pictures were best taken with a twin-lens camera. The further away the object, the further apart the lenses had to be. Seen through a twin-lensed viewer the two separate pictures were reconstituted to give an appearance of solidarity. As with many developments there was a pioneer, Sir Charles Wheatstone, and an inventor proper, Sir David Brewster, who introduced stereo photography in the 1850s. The first effective stereoscopic viewer was introduced by the Parisian optician Jules Duboscq in 1850. By 1900 manufacturers were producing crank-operated stereo viewers, some of them coin-operated for commercial use. Stereo cameras continue, to be manufactured until 1926, which was the year of the Rolleidoscop, precursor of the Rolleiflex (by Franke & Heidecke of Brunswick).

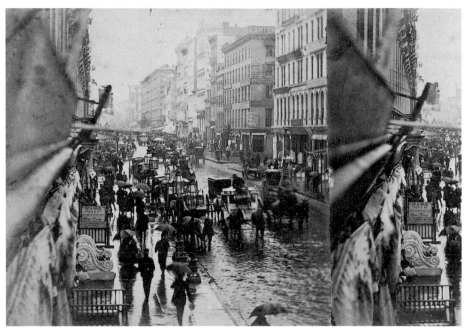

Braun had made floral designs for the textile business; and Anthony had an important studio in New York in the early 1850s.

The Anthonys and New York City

Edward (1818–88) and Henry T. (1813–84) Anthony have only been given a modicum of attention in the history of the medium. They seem, however, to have been the first photographers of New York City, and the virtual inventors of street photography late in the 1850s, of the street as a social scene, that is, rather than as a stage for vividly realized individuals, as it was to become in the 1960s. Robert Taft mentions the Anthonys in his conspectus of 1938, *Photography and the American Scene*, and prints two Anthony pictures from 1859, one of *Broadway on a Rainy Day, Instantaneous View No. 213* and another of *Blondin on a Tightrope over Niagara, Instantaneous View No. 125*. The Anthonys' American and Foreign Stereoscopic Emporium was at 501 Broadway, New York, and from there they published what were variously called Instantaneous or Stereoscopic Views. Who took their pictures is not always, or even very often, clear, but one of their cameramen was T.C. Roche, a Civil War photographer, who also worked for the famous entrepreneur Mathew Brady. One picture by Roche forms part of an Anthony series, 'A Visit to the Central Park in the Summer of 1863'. That suggests that the Anthonys were publishing scenes from daily life in New York City during the Civil War, at a time when American photography was usually considered to be preoccupied by grim actualities. In addition, it means that the Anthonys'

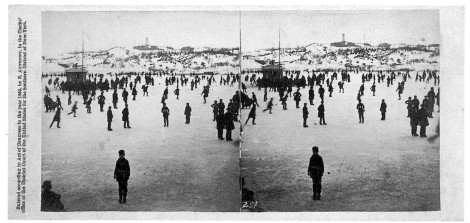

E. & H. T. Anthony
Skating Scene in Central Park. From
Stereoscopic Views of New York,
c. 1860. Stereocard.
Dimensions of card: 85mm × 175mm
(from the Collection of the
National Museum of Photography,
Film & Television)

street pictures precede by a decade all those survey pictures of the American West which figure so heroically in photographic history. If the Instantaneous Views are to be incorporated into the history of the medium, the role they play has to be dialectical. They were part of a discourse in which the city, thought of as epitomizing civilization, stood in a complementary relation to the War. What the Anthonys did in New York was to point out what was at stake, at least in terms of civic amenity. Roche's picture of Central Park, for example, must have been taken at around the time of Gettysburg, which was fought in early July 1863. The Anthonys were also highly successful businessmen, and for around 50 years they served as the leading suppliers of photographic materials to the American trade. Taft maintains that they supplied both Brady and his Confederate counterparts. Brady is known to have been in debt to them, and to have given them a set of his stereographic negatives of the War in part payment. Their company survived, and in 1901 merged with the Scovill Manufacturing Company, which in 1907 became the Ansco Company, which in turn merged with Agfa in 1928 to form the Agfa Ansco Company, principal competitor to Eastman Kodak.

The Anthonys' street photographs are as intriguing as any group of pictures ever taken. They gaze out from first-floor windows or balconies, and feature passers-by and the horse-drawn traffic of the era, generally on quite ordinary days. One of the Anthonys' better known pictures depicts rain on Broadway, looking down on umbrellas and on reflections on the wet pavements. Although these may be the first candid pictures of street life, candour hardly seems to be their point, for they have little to say about social behaviour, other than that the streets and the parks were crowded in all weathers. Some of the other pictures the Anthonys made or had made of New York City at the time, were taken at ground level, and are interesting as documents, for they can be analyzed and read in detail. Yet artistically the first-floor views are far superior. Seen from above, even from just one flight of steps up, the street stretches to infinity or, in 1860, into a pale misted distance. This means that the commonalty, passing by on the pavement,

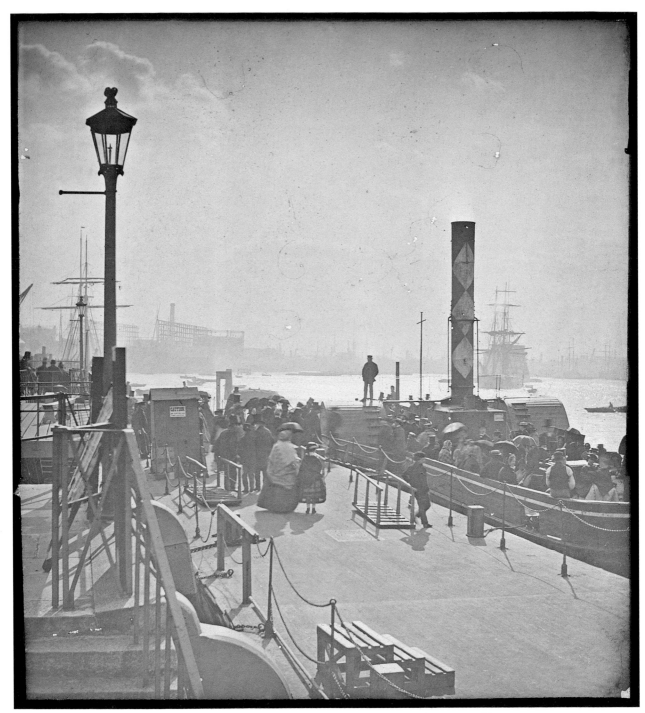

George Washington Wilson. *At Greenwich, London (the arrival of the boat)* 1857. Collodion positive. 76mm × 69mm
(courtesy of the Royal Photographic Society, Bath)

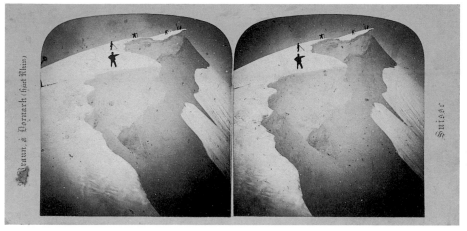

A. Braun
Alpine Scenes: Sommet de Galenstock,
1860–70. Stereocard.
Dimensions of card: 85mm × 175mm
(from the Collection of the
National Museum of Photography,
Film & Television)

are seen to exist in relation to a whole, although a whole which is more planetary than social. The ground-level pictures, by contrast, are altogether more fragmentary and express the metropolis as an aggregate of fragments or as a whole which might be tabulated. The long-range street pictures touch on an eternity or global destiny in relation to the representative citizens of Broadway and of Greenwich Pier, where George Washington Wilson took some of his most striking pictures in the late 1850s.

Some of these early stereo operatives might be taken for romantics, just like such precursors and contemporaries as Roger Fenton and Gustave Le Gray, who made their art around the unequal relationship between humanity and the natural environment. There are Le Gray's ocean scenes, for example, with their tiny ships. The difference, however, in around 1860 and thereafter, was that the stereo ethic was impatient of tragedy and of melodrama. The citizens of Broadway and of the Boulevard Haussman, like the travellers on Greenwich Pier, simply go about their business unaffected by the idea that the street stretches to infinity and that they might form any part of a symbolic scene.

The Alps and the West

Stereo men and women were unabashed by their supernumerary roles in the global whole, which appears to have been imagined more or less as a backdrop against which representative contemporaries could be seen to advantage. Stereo's very own heroic genre features the alpine guide, who was introduced in the 1860s by Adolphe Braun and William England and thereafter became part of stereo's stock in trade. The alpine guide, at Chamonix or on Mont Blanc, appeared, preferably, at the head of a string of clients who were arranged across a potentially dangerous snowscape, marked by cornices, glaciers and crevasses. Although both guides and clients were dressed for the weather and the place, most of them still managed to look like the bourgeoisie on an outing, placing the imprint of their lifestyle on

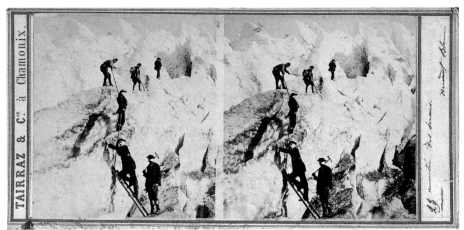

Tiarraz of Chamonix
Alpine scenes: Mont Blanc,
1860–1870. Stereocard.
85mm × 175mm
(from the Collection of the
National Museum of Photography,
Film & Television)

Nature untamed. The American equivalent to the alpine guide was either a surveyor or an engineer placed self-confidently within the gigantic scenery of the West. The alpine guide, by contrast, was always a bravura figure who did little that was useful; his point was purely his appearance and he was untainted by the kind of practical considerations which clearly mattered in the USA.

Stereo's strategy was to take up and to experiment with respectable formats and to make them familiar and accessible. Thus the guide, for example, is a folkish version of all those heroic and bohemian writers, painters and musicians who feature in Nadar's cultural pantheon. In the late 1850s Nadar photographed all the artists of note in Paris, as well as the writers and musicians. And yet not everyone could claim to be familiar with Theophile Gautier or Hector Berlioz. An alpine guide, on the other hand, could be encountered by any bourgeois on holiday.

City Lights

Architecture was another important element in the metropolis and especially in Paris, which was being remodelled by Baron Haussmann from the mid-1850s onwards. The new architecture of opera houses and civic buildings was imposing in its neo-Renaissance style and meant to project the power and culture of the state. Photographers were intended to keep records, especially of the new Bonapartist Paris in construction, and the handsome pictures that resulted have been coveted by the great museum collections of the post-modern era. Less valued by these institutions are the stereo tissue cards of the late 1860s. These are transparent and coloured, pierced and modified by inserts of tinted film. New stereoscopic viewers were developed in conjunction with these cards. In these the card was placed in front of a translucent screen, and light could be reflected onto the surface of the card by a manoeuvrable mirror mounted above. Light from the mirror shone onto the front of the card and presented its subject in daylight, but by closing the

Lón Levy Paris
La Place du Marché, Copenhague,
c. 1860.
Illuminated stereocard.
85mm × 175mm
(from the Collection of the
National Museum of Photography,
Film & Television)

mirror and turning the translucent screen towards the light, daylight could become twilight or even night, and lamps came on in the windows and began to shine through open doorways. Cities and their buildings appeared transformed and enchanted under this kind of magical lighting, and seem like prefigurations of Coney Island, Blackpool and all those other illuminated resorts of the modern era. What effect these fantastical cityscapes must have had on young, and any other, audiences can only be imagined. Even the most strait-laced buildings (such as the Pantheon in Paris) were projected as carnival attractions. The building itself may have been meant to express the authority of the state, but this sort of entertaining treatment rephrased the experience on a spectacular and personal basis.

Aesthetically speaking, stereo stressed point-of-view and individual experience. Pictorial photographs, such as those taken by Gustave Le Gray in the 1850s, were, by contrast, tableaux whose varied elements could be examined at leisure. In stereo-viewing, the climax was reached when depth was grasped or focus achieved, and this sense of sudden revelation was enhanced in lighted stereo and tissue pictures where you were also privy to the lighting of the lamps. Nor did stereo's epiphanies depend on major subjects; almost any item free-standing in space would do, or an open road or a set of steps. Stereo-viewing was premised both on the grasping of appearances and on the pleasures of captivation. It was the moment of clarification which counted, to be followed by another and another. What stereo excluded was any kind of equable relationship with the world out there. Phenomena had to be compelling to get onto the stereo register, although the taste for sensation waned towards the 1890s, softened by the documentary impulse. It was this extravagance in stereo which prompted the rise (also in the 1890s) of a new pictorialism or soft-focus photography which took intuition into account. From then on it was possible to come quietly to terms with appearances, on a basis of mutual acknowledgement. What this amounted to, in effect, was an admission of spirituality on the part of a new generation of artists, who were hopeful that there was more to phenomena than met the stereo eye.

Even if stereo did introduce photography to the wider public, it ought not to be denigrated. Complaisant and entertaining though it was, especially towards the beginning, it can hardly ever be described as kitsch. It is only in quasi-art

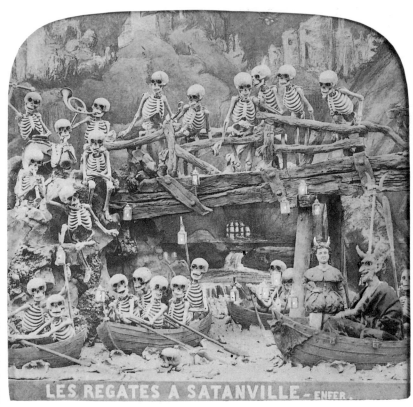

LES REGATES A SATANVILLE - ENFER.

photography from the 1860s onwards, by Henry Peach Robinson, Oscar Rejlander and Mrs Cameron, that the kitsch virus becomes identifiable. By the 1890s it had become widespread in art and salon photography, where it led by reaction to the formation of secessionist and other avant-garde movements. Stereo was in general far too companionable ever to be accused of bad taste, and it may even have amounted to a people's art, sceptical of the pretensions of grand art as it was projected in Paris, for example, in the Salons of the 1860s. Stereo's Sistine Ceiling is called *Les Diableries* and is made up of a set of 72 cards published in Paris in 1861. Based on tableaux devised by Hennetier (whose name can sometimes be seen carved on plaster pedestals) *Les Diableries* features a cast of skeletons acting out parts in the French social scene: returning from the races, spectating at a regatta, participating in the vendage. With its red-eyed cast in rough-hewn settings, *Les Diableries* looks like a proto-Dadaist pastiche based on and even aimed at the refined neo-classicism which was popular in Paris in the 1850s and 1860s. Prince Jérôme Napoleon, cousin of the Emperor, had a Mason Pompéienne on the avenue Montaigne in Paris decorated with classical subjects. Pompeii, which had been excavated in the late eighteenth century, was something of a craze amongst Salon painters in the 1850s and was the subject of the illustrated *Les Ruines de Pompeii*, published from 1827 onwards.

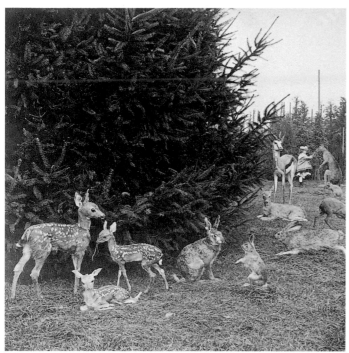

Eadweard J. Muybridge
Animals at Woodward's Gardens, c.1869.
Stereocard (detail). 85mm × 175mm
(from the Collection of the National
Museum of Photography, Film & Television)

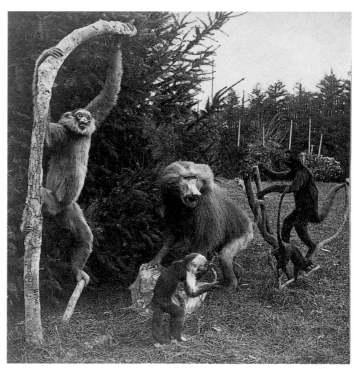

Eadweard J. Muybridge
Monkeys at Woodward's Gardens, c.1869.
Stereocard (detail). 85mm × 175mm
(from the Collection of the National
Museum of Photography, Film & Television)

Celestial Photo0graphy

Warren de la Rue
Lunar photographs, 1857–62.
Stereocard. 85mm × 175mm
(from the Collection of the
National Museum of Photography,
Film & Television)

Wet-collodion process

This was an important negative
process invented by the British
photographer Frederick Scott
Archer in 1851. Collodion was a
mixture of nitrocellulose dissolved
in ethyl ether and ethyl alcohol.
It was sensitized by the addition
of silver iodide and applied to a
glass plate just prior to exposure.
Wet-collodion negatives were
notably sharp; the difficulty was
that the process was cumbersome
and entailed a portable darkroom
if pictures were to be made away
from the studio. The wet-collodion
process was in use from the
mid-1850s until 1870. Dry plates
were introduced during the
1870s. Dry collodion was slower
and less sensitive than the wet
process, but more convenient.

Photography had its serious side too. The history of celestial photography, as it was known in the 1890s, is virtually coterminous with that of the medium itself; and it is also a history of firsts, sometimes excessively so. There was a straightforward agenda of photography listing the moon, the sun and the stars in that order, with eclipses and comets providing the main interruptions. The stars were arranged in order of magnitude, with those near to the limits of ordinary eyesight said to belong to the sixth magnitude, and the brightest to the first. In 1850 the Americans Bond and Whipple, using the equatorial telescope of the Harvard Observatory, tried not very successfully to make daguerreotype photographs of the stars. Unfortunately their medium was too insensitive for starlight. By 1857, helped by the recently introduced wet collodion process, Bond had succeeded in taking pictures of stars to the first and second magnitude, with an exposure of only two seconds. Further and fainter stars were of even greater interest to astronomers, and in 1864 Dr Rutherford of New York, using a lens of eleven inches aperture, took good pictures of the Praesepe and the Pleiades, registering stars down to the ninth magnitude, only visible to the aided eye. In 1870 and in 1882 a Dr Gould, based at the Cordoba Observatory in Argentina, photographed stars to the tenth and eleventh magnitudes. Some of his pictures contained 500 stars to the square degree. Progress continued, helped along by technical developments, such as the introduction of gelatine-bromide dry plates in the late 1870s.

Encouraged by what could be learnt from celestial photography, astronomers determined to make a complete map of the whole sky. The idea seems to have occurred first to Warren de la Rue in 1857. He had established an observatory at Cranford in England in 1856, and had taken good pictures of the Moon, Jupiter and Saturn. His Moon photographs were distributed on stereocards. In 1859 he also set up a photo-heliograph at Kew, a specialist camera with filtered lenses which allowed him to take over 2,000 pictures of the Sun's surface between 1862 and 1872. For every imaginable reason the Sun was of great interest to observers, but there was a special interest in sun-spots because of their influence on the Earth's magnetic field. Sun-spot activity interrupted telegraphy and was thought to impact on consciousness itself. Leopold Bloom, who took the part of Ulysses in James Joyce's *Ulysses* (an account of a day in Dublin, 16 June 1904), often thought of the stars and twice of sun-spots during that extended day. At one point he even wondered how he might get into the good books of Professor C. J. Joly, the Astronomer Royal of Ireland, who had himself taken pictures of the solar corona of May 1900.

Photographically based maps of the stars had first been made by M. C. Wolf in the Paris Observatory in 1874. Wolf worked on his scheme for three years and placed around 1,000 stars. Then the brothers Paul and Prosper Henry, also of the Paris Observatory, devised a more effective scheme whereby photographic plates

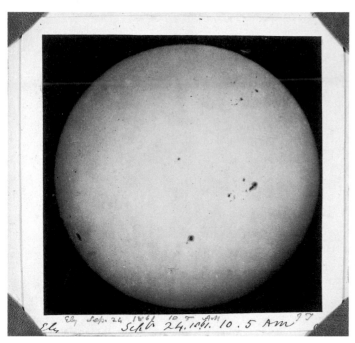

Ely Sep. 24 1862 10 T AM
Sept 24.1841. 10.5 Am

John Titlington
*Autograph of the Sun for the
Rev. William Selwyn of Ely*, 1862.
Albumen print. 127mm × 127mm
(from the Collection of the
National Museum of Photography,
Film & Television)

were exposed three times over, registering each star as a triangle. The aim of the process was to eliminate photographic defects. The Henry brothers and Dr David Gill, director of the Cape Observatory, then revived the idea of surveying all of the heavens. Gill had noticed in the early 1880s what good results could be obtained by attaching a camera to the equatorial telescope of the observatory, which was driven by clockwork to counteract the earth's motion. The use of clockwork allowed for long exposures which revealed distant and unsuspected stars. In 1887 an International Conference of astronomers was held in Paris to arrange the details of a photographic chart of the whole heavens on a uniform plan. At first the idea was to photograph two series of stars, one down to the eleventh magnitude and the other down to the fourteenth. It was originally anticipated that the scheme would take several years, but by 1902 there were thought to be 25 years of work still to be done. In 1887 the astronomers announced that they would have to expose 11,000 plates, and that the final photographic map would form a pile of paper 30 feet high and weighing nearly two tons. The conference was attended by astronomers from 16 countries, and 18 observatories were selected to do the work. In addition to any scientific value which the project had, it was an extraordinary example of international co-operation, headed by a Frenchman, Admiral Mouchez, Director of the Paris Observatory.

One of the difficulties which the project encountered was that technical improvements kept revealing more and more stars. In 1887, for example, Dr Isaac Roberts, used a reflecting telescope of 20 inches aperture to make a plate of a portion of the Milky Way in Cygnus, with an exposure of one hour. He revealed

William Crookes and polarization (see p.10)

These are copies of glass negatives made in 1853 by the wet collodion process. They were taken on a camera-polariscope combination exposed facing skyward for between half an hour and two hours in broad daylight and rotated 90 degrees every few minutes in the interests of uniformity. Polarization refers to the organization of the electro-magnetic properties of light. Reflected light is polarized, which is to say that its electro-magnetic field is arranged at right angles to its line of flight or direction. The same happens when light passes through certain crystals. It seems in these negatives as if a beam of light has been separated and then re-integrated and that Crookes has been interested in the interference patterns brought about on re-combination. The virtue of photography, according to Crookes in 1853, was that it gave more information on polarization patterns than was available from simple visual inspection in a polariscope.

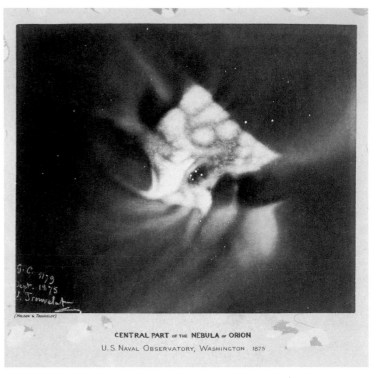

CENTRAL PART of the NEBULA of ORION
U.S. NAVAL OBSERVATORY, WASHINGTON. 1875

Louis Trouvelot
The Orion Nebula, 1875.
US Naval Observatory, Washington.
Photograph of a pastel drawing.
165mm × 190mm
(Science Museum/Science
& Society Picture Library)

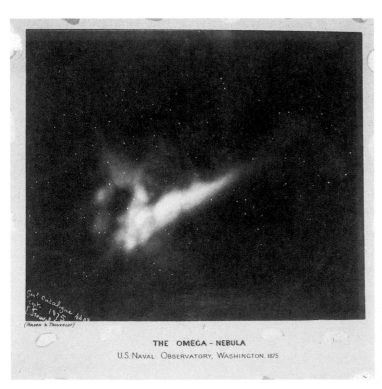

THE OMEGA – NEBULA
U.S. NAVAL OBSERVATORY, WASHINGTON. 1875

Louis Trouvelot
The Omega Nebula, 1875,
US Naval Observatory, Washington.
Photograph of a pastel drawing.
165mm × 190mm
(Science Museum/Science
& Society Picture Library)

Paul and Prosper Henry
Stars in the Constellation of Cassiopeia,
November 1883, Paris Observatory.
305mm × 245mm
(Science Museum/Science
& Society Picture Library)

over 16,000 stars on a space of about four square degrees. Another problem, in 1887 was what sort of lens to use for the scheme. The astronomers opted for refractors rather than the superior doublet, which with four lenses had eight optical surfaces, all of which had to be optically true. In 1889 the Harvard Observatory obtained an expensive doublet of 2 feet aperture, which was greatly superior to anything else in use in the project. A further difficulty was that, due to the very long exposures necessary to register the furthest stars, the nearer and larger stars often appeared over-exposed. Red stars, too, seemed much smaller than they actually were, at least by comparison with white stars of equal brilliancy. Thus the heavens as photographed had to be interpreted with a knowledge of relative sizes. Spectrum analysis was also needed to identify the gases in question and to measure velocities and directions. (On 27 July 1842 Professor J. W. Draper, who had made the first successful daguerreotype of the Moon in 1840, paired spectroscopy and photography in a daguerreotype record of sunlight directed through a prism.) And then there were 'composition pictures', synthesised by artists from a number of photographic exposures of the rim of the sun taken during eclipses. Photography, which had always seemed like a reliable record of appearances, featured increasingly as a matter for specialist interpretation or inference.

The numbers involved in the photographic chart of the heavens were, in a manner of speaking, astronomical. The first series of plates, going to the eleventh magnitude, would include one and a half million stars. The second set, including

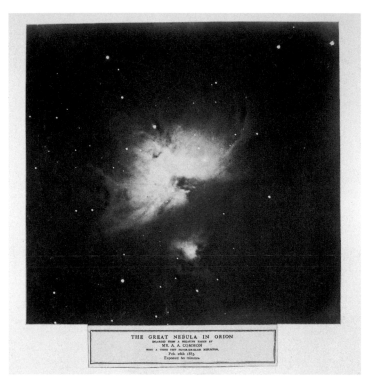

THE GREAT NEBULA IN ORION
ENLARGED FROM A NEGATIVE TAKEN BY
MR. A. A. COMMON
WITH A THREE FEET SILVER-ON-GLASS REFLECTOR.
Feb. 28th 1883.
Exposure 60 minutes.

A. A. Common
The Orion Nebula, taken February 1883 using
a telescope in the garden of his home in Ealing, London.
345mm × 355mm
(Science Museum/Science & Society Picture Library)

Anon
The Great Nebula in Carina,
4-hour exposure, 1909, Royal Observatory,
Cape of Good Hope, South Africa.
420mm × 420mm (Science Museum/
Science & Society Picture Library)

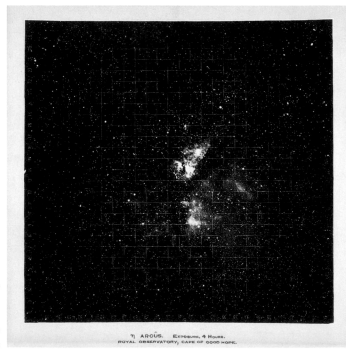

7] ARGUS. Exposure, 4 Hours.
ROYAL OBSERVATORY, CAPE OF GOOD HOPE.

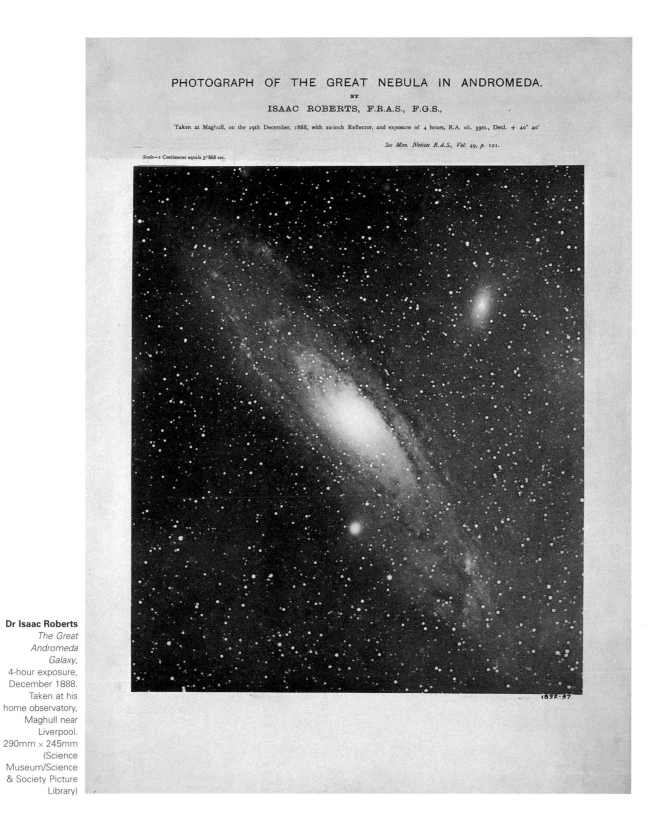

Dr Isaac Roberts
*The Great
Andromeda
Galaxy*,
4-hour exposure,
December 1888.
Taken at his
home observatory,
Maghull near
Liverpool.
290mm × 245mm
(Science
Museum/Science
& Society Picture
Library)

stars to the fourteenth magnitude, would (it was estimated) include about 20,000,000 stars. But whilst this gigantic scheme was under consideration, the aesthetic high ground in celestial photography was taken by the nebulae. The faster dry plate processes had put these within reach, and in 1881 Professor Draper obtained a good photograph of the Great Nebula in Orion using an exposure of one hour. A better photo of the same nebula was taken by Dr Common of Ealing in January 1883. Common, together with Dr Isaac Roberts of Crowborough in Sussex, was a leading light in the golden age of celestial photography. In 1888 Roberts took a picture of the Great Nebula in Andromeda, showing what looked like an original mass breaking up into rings of nebulous matter. Interestingly, Roberts' photographs of the Andromeda nebula showed a spiral form. Spiral nebulae had been discovered earlier in the century by the Earl of Rosse (the same notable who had written to Fox Talbot in 1852 asking him to relinquish his patent rights over the negative-positive process). Expanding or contracting, the spiral nebulae were marvellous and mysterious, and after the pioneering work of Common and Roberts they were photographed in even greater detail by G. W. Ritchey at the Yerkes Observatory in Chicago and by J.E. Keeler at the Lick Observatory in California. Keeler at the Lick used a three-foot reflector, which had formerly been the property of Dr Common at Ealing. From Ealing it had gone to a Mr Crossley of Halifax, and thence to the brighter skies of California.

These photographs of the 1880s and 1890s appeared to confirm Laplace's Nebular Hypothesis on the formation of solar systems. Nebulae in general had been known about since the origins of astronomy and the Great Nebula of Andromeda (31 Messier to astronomers) had been mentioned in AD 905 by the Persian astronomer Al-Sufi; but it was photography which made them known to the public. In Sir R.S. Ball's *Popular Guide to the Heavens* of 1905 this remark on the Great Nebula in Orion appeared: 'In the telescope it is a splendid object, full of intricate detail. But to bring out its full beauty we must, as always with the nebulae, photograph it.' Once photographed, these formations could be described, although they remained a test of language. Ball's descriptions are objective: 'We find black holes with edges surprisingly sharp which are very hard to explain,' was said with respect to the Great Nebula in Orion. Earlier astronomers, such as Sir William and Sir John Herschel, were far more grandiloquent. It was Sir John Herschel who devised the term 'photography', and who brought 'negative' and 'positive' into the language of photography. But by the 1890s the words which had introduced the heavens to people in the 1830s had been superseded by images, in particular those of the newly observable nebulae. J. E. Gore's *The Worlds of Space*, published in 1894 as a series of popular articles on astronomical subjects, opens with a picture of the spiral nebula in Canes Venatici (51 Messier, and situated in a constellation 3 degrees south west of the star at the end of the Great Bear's tail). Gore described it as 'perhaps the most remarkable of these wonderful objects'. Also relevant culturally is the fact that the spiral nebulae popularized an idea of patterned energy.

These were thought to be galaxies in creation, or 'nebulosities running into each other, as if under the influence of a condensing power' (as Admiral Smyth wrote in his *Celestial Cycle*). The spiral appeared to mirror the very pattern of creation, and it gained hugely in prestige amongst writers and artists. The first modernist movement to draw on the kinds of energies featured in this new branch of astronomy was Vorticism, signalled by the theorist Ernest Fenellosa around 1904 and given shape by Ezra Pound and Wyndham Lewis later in the decade. The spiral itself continued to be the stuff of advanced art theory well into the 1930s, as a cosmic principle embedded in consciousness and the key to 'oneness with life', a phrase from *The Simplified Human Figure*, Adolfo Best-Maugard's 1937 book on 'intuitional expression'. Writing at some point in the early 1930s for the *feuilleton* section of the *Frankfurter Zeitung* in an article translated into English as *Analysis of a City Map*, and published in the *Mass Ornament*(1995) Siegfried Kracauer considered the city's streets (Paris) with their crowds in terms of the nebulae: 'On Saturday afternoons the avenue St. Ouan is a fairground. Not that the fair simply set itself up here like a travelling circus; rather, the avenue was pregnant with it and brings forth the fair from within itself. The need to lay in supplies for Sunday brings together a crowd that would appear to astronomers as nebulae. It jams together into dense clumps in which the tightly packed individuals wait, until at some point they are again unpacked. Between purchases they savour the spectacle of the constant disintegration of the complexes to which they belong, a sight that keeps them at the peripheries of life.' This organic or natural interpretation of crowd behaviour would soon be out of fashion in the totalitarian 1930s.

Lunar Objects

The moon figures in early histories of celestial photography, but not to any great degree. Daguerre attempted to photograph it in 1840, but the first successful daguerreotype was not taken until Professor J. Draper succeeded later in that year. After that, it features regularly on stereocards, and then in 1874 in James Nasmyth's photographs in *The Moon considered as a Planet, a World and a Satellite*, by Nasmyth and James Carpenter. Nasmyth's pictures, however, were taken not from nature but from plaster models of the lunar surface. By 1905, such were the advances in celestial photography that a model would have been unnecessary. Ball's *Popular Guide to the Heavens* of that year is illustrated with close-ups taken via a 40-inch refractor at the Yerkes Observatory. By then the moon, distant though it was, was known in detail through a catalogue of some 454 lunar objects (craters, that is, named after astronomers, philosophers and ancient notables), mountain ranges and seas. The pock-marked lunar surface looks like nothing so much as a premonition of the aerially observed landscapes of the Great War. Perhaps in the economy of celestial photography the desiccated and pitted moon, a ground for those hundreds of commemorative names, represented inertia or an old

**James Nasmyth &
James Carpenter**

*Plate II: Back of Hand and
Wrinkled Apple,* from *The Moon
Considered as a Planet, a World
and a Satellite,* second edition,
published 1874. Woodburytype.
Dimensions (each image):
94mm × 76mm
(from the Collection of the
National Museum of Photography,
Film & Television)

world become moribund, at least by comparison with the spiralling and clustering nebulae. It is as if the stars, moving outwards from the stultified moon, could be understood as representing culture as it was then evolving, with the new vanguards (Vorticism in particular) taking the part of those evolving clusters in the Pleiades, in Andromeda, Cygnus and Orion.

In *Art in Crisis: the Lost Centre,* a book published in English in 1957, but made up of writings from the 1930s and after, Hans Sedlmayr, a prominent art historian of the era, wrote of the moon as an important symbol of alienation in modern art and life: 'The human warmth has gone out of man's relation to created things. The moon, itself a dead body, coldly reflecting the light of a sun that has set, veiling the world in a shroud, is the chief symbol of this new feeling that man has about them. Man feels himself abandoned by God.' Sedlmayr was thinking, at the time, of the German romantic painter Caspar David Friedrich, but his diagnosis would have been even better applied to the moon, and its plaster surrogate, photographed in the late nineteenth century.

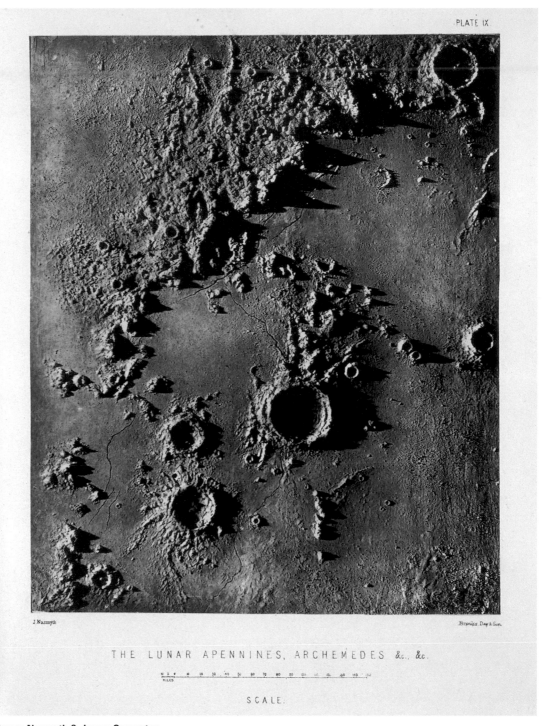

PLATE IX.

J.Nasmyth Bropoiss Day & Son.

THE LUNAR APENNINES, ARCHEMEDES &c., &c.

SCALE.

James Nasmyth & James Carpenter
Plate IX: The Lunar Apennines, from *The Moon Considered as a Planet, a World and a Satellite*, second edition, published 1874.
Woodburytype. 145mm × 102mm (from the Collection of the National Museum of Photography, Film & Television)

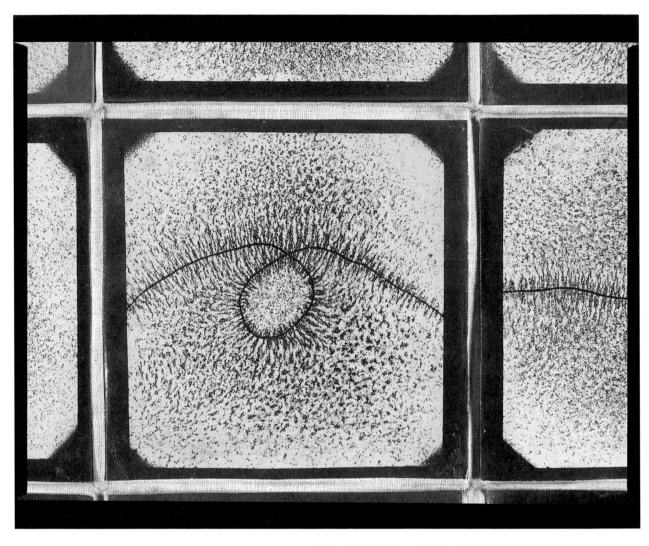

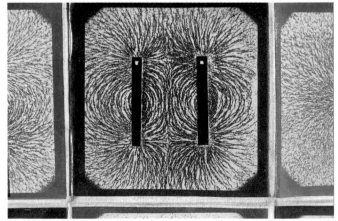

Anon
Iron Filings around Magnetic Fields (details),
taken for Professor Sylvanus Thompson,
c. 1870. Albumen prints. 76mm × 76mm
(from the Collection of the National
Museum of Photography, Film & Television)

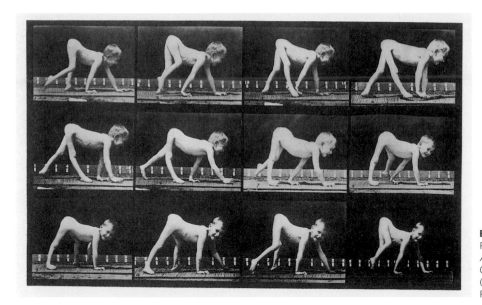

Eadweard Muybridge
Plate 539 from
Animal Locomotion 1887.
Collotype. 210mm × 348mm
(courtesy of the Royal
Photographic Society, Bath)

Chronophotography: stopping time

Chronophotography, or the taking of figures in movement, also developed at this time, and in 1887, the same year that the astronomers met in Paris to plan the mapping of the heavens, Eadweard Muybridge's *Animal Locomotion* was published. Muybridge's was a large-scale project, comprising 11 volumes, with 781 gravure pages illustrating 20,000 phases of locomotion. At 110 guineas it was expensive, although there was a smaller edition costing 20 guineas which contained selected pictures of human beings. *Animal Locomotion* has a solid place in the history of the medium, in part because this kind of serial photography led to the development of cinematography. Muybridge's contribution was the Zoopraxiscope, an invention of 1879, in which concentric rows of transparent positive pictures were mounted on a disc and projected one after another onto a screen. Muybridge used batteries of cameras pointing towards calibrated walls, against which his subjects walked, jumped, ran, wrestled and climbed short flights of steps. His exact contemporary in France, Etienne Jules Marey, undertook similar experiments although using much more sophisticated equipment. Marey had one camera which had a moving plate behind a lens, fronted by a disc measuring 4 feet in diameter. The disc was perforated and able to revolve at ten revolutions per second, giving exposures of $1/1000^{th}$ of a second. Photographed at speed and onto a single plate, his subjects were superimposed. From 1890 he used negative paper for his exposures instead of glass plates, although he was unable to project the results because transparent film material was still inadequate to the task.

These experiments with time and motion seem, with hindsight, to be quite straightforward, part of photography's destiny. What could be more natural, the

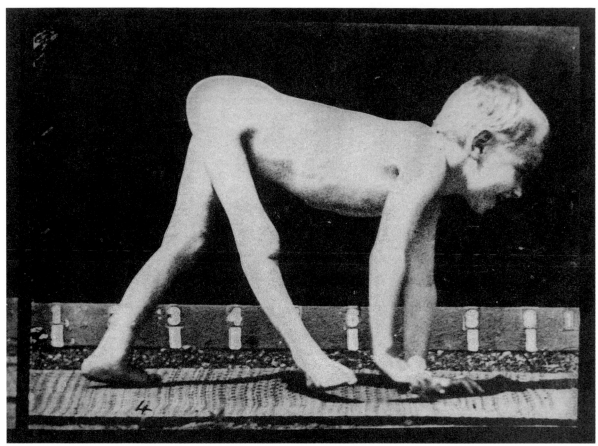

Eadweard Muybridge
Detail of plate 539 from
Animal Locomotion 1887.
Collotype
(courtesy of the Royal
Photographic Society, Bath)

technical histories imply, than that inventors should want to take pictures at unbelievably high speeds of explosions and of bullets exiting guns, electric light bulbs, balloons, apples? Chronophotography took place, or so the story goes, for some greater good, although on inspection it seems more likely that it was a development carried out for its own sake, or was predictable and therefore inevitable. Muybridge's myriad experiments with moving figures were undertaken, it is said, because they might prove useful to artists, who would be keen to see exactly how a naked woman, for instance, might climb or descend a staircase, the subject of Marcel Duchamp's famous painting of 1912, *Nude Descending a Staircase*.

What is easily forgotten is that the photography of time and motion was a contradictory project, intended both to represent movement as it originally was, within its own time, and also to bring movement to a standstill so that it might be more easily analyzed (or just appreciated). Muybridge's scheme, in particular, seems to exceed its brief. Not only did he photograph any number of near-identical events but he also took them from a number of different angles, resulting in a comprehensive survey of routine movements. Why should anyone wish to be exposed to such exhaustive accounts ? Evidently people did, and Muybridge became

sufficient of a celebrity to occupy a building of his own at the Chicago World Fair in 1893. What he and Marey proposed, in fact, was a conquest of time, or the impression that time could be managed and decelerated. Time had always been notoriously evanescent and slippery, and something of an offence to humanity. Artists in the 1880s and 1890s seem to have resolved to take the matter in hand, and achieve some kind of mastery. Merely to watch time slip away, in the Impressionist style, was no longer enough. Georges Seurat's solution in the 1880s was to capture weekend subjects on the riverbanks and in the parks of Paris, and to represent them monumentally, as action tableaux so slowed down as to have come to a stop. Seurat's preference was for objects fixed and tethered: a freighter, for example, moored at a quayside. Muybridge's strategy was to convert movement into a mosaic, to make its separated parts manageable as if part of a board game. Muybridge's early pictures were taken out of doors, and showed horses in movement, but most of his work, with its calibrated backgrounds, looks as though it has been carried out in a laboratory. It is this controlled aspect which links *Animal Locomotion* with modernism as it was conceived in the 1920s: an aesthetic of control and management in which humanity, marshalled by designers, rehearses for a utopian destiny. The project in Muybridge's era, however, was more modest, for its aim was merely to exert control at a remove over representations of time. In 1897 his contemporary, the French poet Stephane Mallarmé, introduced his controversial poem, UN COUP DE DES JAMAIS N'ABOLIRA LE HASARD (A dice-throw never will abolish chance) with these words: 'The literary advantage, if I may call it so, of this copied distance which mentally separates groups of words or words from one another seems to be from time to time the acceleration and the slowing up of the movement, stressing it, conveying it even according to a simultaneous vision of the Page: the latter being taken as a unit as is elsewhere the line of Verse or perfect line.' Mallarmé's poem, which appeared in the Parisian review *Cosmopolis* in May 1897, is arranged over 10 spreads. Its fragmentary lines, often set in different sizes and in varied typefaces, resist sequential reading introducing words and phrases as things in themselves rather than as bearers of meanings. It is not a poem the words of which can be used up, no more than can Muybridge's pieces of action with their deadpan attention to each stage in turn.

One of the disquieting characteristics of Muybridge's photography was that it, like much non-pictorial photography, lacked either spiritual or psychological depth. Muybridge's personnel, moving across their calibrated backgrounds, amount to little more than mechanisms. It was this impersonal side to *Animal Locomotion* which attracted the attention of artists, most notably Francis Bacon, from the 1940s onwards. Muybridge may have meant to explore time and motion, but in the process he gave a relentlessly one-dimensional account of humanity which attracted both 'existential' artists and conceptualists alike. Marey, who hoped to capture and to represent motion, never appealed so strongly: his figures were, relatively speaking, at home in time and space.

Moments of Impact

Muybridge is usually seen as a pioneer in the story of high-speed photography, but he could just as well be identified as the last of the showman photographers. He belonged to a generation which still thought in terms of the public at large, the public targeted by the great exhibitions inaugurated in 1851. This culture was premised on international trade and a comity of nations, but it was undermined by 'the scramble for Africa' and intensified rivalries between the great powers. Photography had scarcely mattered under those old terms of reference: Muybridge's career in 'science' for instance, was prompted by nothing more than curiosity on the part of Leland Stanford, Governor of California, as to how exactly horses placed their feet when galloping. Gradually, however, it was realized that high-speed photography had relevance in industry, and especially in the manufacture of armaments, which depended on synchronization at high-speed. Using electrical sparks, scientists practised on splashes (usually made by metal pellets entering milk) and bullets at the moment of discharge. There were famous names involved, such as that of Ernst Mach, who was Professor of Physics at the Physical Institute in Prague. From 1881 he studied the flight of projectiles. As the result of these purely technical experiments, high-speed photography evolved a strange iconography of bullets and bubbles. Bullets were a real challenge, because they travelled at speeds of between 2,000 and 3,000 feet per second and it was difficult to produce a spark of brief enough duration to make a clear picture of the projectile with its shock waves. (In contrast a bullet from a Martini-Henry rifle only achieved 1,250 feet per second, according to Professor C.V. Boys in an article entitled *Photography of Flying Bullets, etc.*, published in *The Photographic Journal* on 30 April 1892.) Bubbles, on the other hand, rarely broke at speeds in excess of 40 to 50 feet per second, and they, together with moving drops and splashes, constituted something like a pastoral pre-history of high-speed photography.

The Great War put a premium on research into armaments, and ensured that developments, which were not a matter of national security, went unpublished. New techniques, such as those involving electro-optical shutters, for example, also took much longer to bring to completion, and could not be announced publicly as they had been throughout most of the nineteenth century. In the 1890s, for example, discoveries had been made and declared under the names of individuals: Wilhem Röntgen, the discoverer of X-ray photography in 1895, is the best known instance of this. Despite the secrecy, developments in high-speed photography continued and they culminated in the great breakthrough of 1930: the gas-discharge tube or strobe invented by Harold Edgerton at the Massachusetts Institute of Technology. The virtue of Edgerton's invention, which involved discharging an electric current into a mercury- and argon-filled tube, was that it gave more light at high intensity than could be achieved using spark photography.

Stroboscopic lighting

From the Greek *strobos* meaning whirling. High-speed lighting was developed to test machinery, especially revolving elements in engines which had to be inspected for unwanted vibration. Spark lighting was used at first, but from 1930 gas-discharge tubes came into use. Harold E. Edgerton, at the Massachusetts Institute of Technology, developed this technique using a mercury arc tube. Flash tubes were then developed for use in still photography: Edgerton's Strobolux lamp in particular. The main function of stroboscopic lighting was to examine machinery in rapid movement and its use in still photography was no more than a spin-off and an advertisement for research into high-technology.

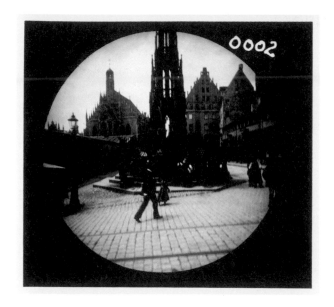
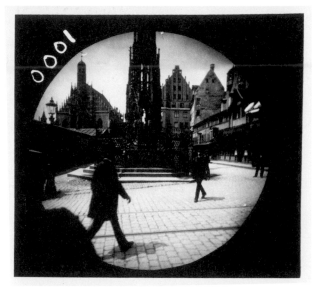

Snapshot photography

Instantaneous or snapshot photography, introduced by the American inventor and entrepreneur George Eastman under the brand-name Kodak in 1889, was altogether more straightforward. As a consequence, it rarely gets more than an honourable mention in histories of the medium. It can and should be maintained, however, that instantaneous photography was as disquieting aesthetically as any other development, including Fox Talbot's calotypes. Eastman had been interested in photography since 1877 and, after a research trip to England in 1879 to look into the production of gelatine dry-plates, he went into business for himself in 1880. Aware of the existence of a general public interested in photography and aware too that this public was both unable and unwilling to learn the process in detail, Eastman set out to make the process more accessible. He experimented with flexible roll film in which a gelatine emulsion was applied to a paper base. In early versions of this process the paper was not removed and its grain showed through on the final positive print. The next step was to develop stripping film, in which the paper support was removed after exposure, and the exposed film was then applied to a gelatine backing. In 1888 celluloid came into use as a backing for gelatine film. The inventor of celluloid was John Carbutt, an Englishman who had emigrated to the USA. Eastman and the Celluloid Manufacturing Company of Newark, New Jersey, began to market Celluloid dry-plates in 1888. Eventually Eastman hired a chemist, Henry Reichenbach, to develop celluloid roll film for Kodak cameras. The production of celluloid rollfilm began in the 1890s, and resulted in prolonged litigation between Eastman and another experimenter in celluloid, the Reverend Hannibal Goodwin of Newark. The case was only settled

Anon
Modern enlargements from early Kodak stripping film negative, *c.* 1892. Silver gelatin prints. Diameter: 127mm
(from the Collection of the National Museum of Photography, Film & Television)

Detective cameras

Portable or hand cameras, which came onto the market in the 1880s and 1890s, were produced by a large variety of makers. Some had automatic plate or film-changing apparatus. The first hand cameras were very difficult to use. The photographer had to assess speed and distance with respect to shutter speed. Distant objects needed depth of focus, which meant a smaller aperture and light restriction. Wide angle lenses also dwarfed the distance and gave exaggerated perspective. Users of these cameras, who included the first newsmen or reportage photographers, rightly saw themselves as specialists. An aura of expertise clung to such photography until well into the 1930s, and was gradually undermined by improvements, such as strobe flash-lighting.

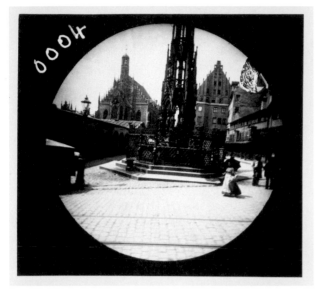

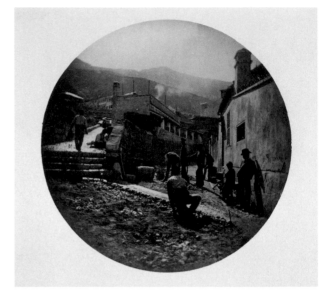

above left:
Anon
Modern enlargement from early
Kodak stripping film negative,
c. 1892. Silver gelatin print.
Diameter: 127mm
(from the Collection of the
National Museum of Photography,
Film & Television)

above right:
Furley Lewis
Gibraltar 1889, modern
enlargement. Silver gelatin print.
Diameter: 102mm
(from the Collection of the
National Museum of Photography,
Film & Television)

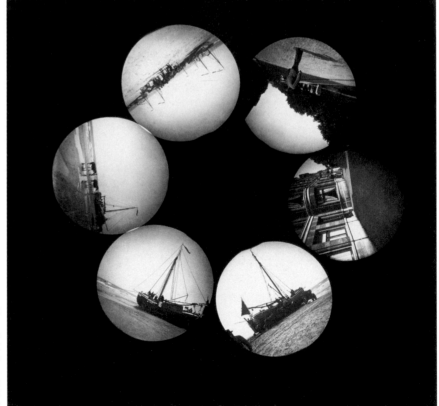

Anon
Contact print on silver-gelatin paper,
1886–92. The Stirn camera was a
concealed 'waistcoat' camera. Recent print
from original negatives held by Deutsches
Museum, Munich.
Diameter of each image: 45mm
(from the Collection of the National
Museum of Photography, Film & Television)

Anon
Original contact prints, *c.* 1892,
on printing-out paper, from a round
Kodak negative, taken with a
Kodak no. 1 camera.
Diameter (of each image): 61mm
(from the Collection of the
National Museum of Photography,
Film & Television)

in 1914, at great cost to Eastman. The rejection of stripping film was due to the complexity of the stripping process which involved the collodionising of a glass base, the squeegeeing of the paper negative onto that base, stripping in hot water and subsequent application of a gelatine backing skin. This complex procedure was too much for the kind of non-specialist buyers Eastman wanted to attract, and it had to be carried out by technicians. Cameras (with the exposed film still inside, were returned to the factory for processing. The Kodak camera was a box covered in black leather (6 ½ inches long × 3 ¾ inches wide × 3 ¼ inches high). An f/9 lens allowed pictures to be taken in good light, and a short focal length of 2 ½ inches gave a good depth of field. The early pictures, on paper-backed stripping film, were made from circular negatives 2 ½ inches in diameter, although this size was soon increased. One hundred exposures could be made on one roll of film. The loaded camera itself cost fifty dollars, and a further ten dollars had to be paid each time it was returned and reloaded.

The remarkable brand name Kodak seems to have been dreamed up by Eastman, although in an entry in E.J. Wall's exhaustive *Dictionary of Photography* of 1897 (seventh edition) it is related speculatively to a Hebrew term for fire and rekindling. The Kodak slogan was 'You press the button and we do the rest'. During its first year of operations the firm sold more than 13,000 Kodaks. In 1890 celluloid-based film in 12 or 24-exposure rolls was introduced, to be loaded by the user. From 1895 this film was marketed in a protective black paper covering, which meant that it could be loaded and unloaded in any light. In 1900 Eastman launched the Box Brownie camera, and sold more than 100,000 of them within the first year. Popular photography had well and truly arrived, and it often seems as if no more need to be said.

The problem which emerged in 1889 was – as it had been in 1839 – one of intention or 'commission'. What kind of pictures could or should be taken with these new cameras? Travellers could buy competent photographs of tourist sites all over the world, and if they were interested in geography and anthropology there were comprehensive sets of stereocards available, which covered almost any topic. That left accidents of travel, encounters, mere contingencies, and it is precisely these subjects that appear on the earliest Kodak rolls: street-scenes, pieces of landscape, small events. In the very early days the difficulties of knowing what to take were compounded by there being 100 exposures to a roll, which was an invitation to profligate shooting. Nor was it clear what should be done with the pictures afterwards, for if they were of minor events of travel they could hardly be cherished. In fact the round Kodak pictures of 1889–90 were little more than reminders or prompts: a hotel in Switzerland, a terrace overlooking an Italian lake, the shore of the Adriatic. That is, a snapshot of 1889 had a moment of maximal use when its author recalled time and place for the benefit of friends, but thereafter it could only fall into desuetude, its narratives forgotten. The more this happens, the more mysterious and even tragic these pictures become, for they exist as evidence of commonplace time, merely lived through. Snapshot photography, at least as practised by Kodak's travellers of 1889–90, revealed an existential vacancy which would have intrigued post-modernist artists a century later. Developments in the 1890s, especially the use of 12- and 24-exposure films, both gave users more control and dissociated photography from the longer reaches of travel with which it was concerned in 1889. Although Eastman may have had nothing more than a convenient format in mind, the 100-exposure rolls of 1889 presuppose travel as Odyssey. Snapshot photography, as it developed subsequently, tended far more towards bearing witness and focused on family and friends.

City Streets

The entrepreneurial Eastman knew from experience that there were markets still to be discovered, but he also knew that their discovery would entail trial and error. He introduced a number of new camera types during the 1890s, several in broad format, ranging up to panoramic. As it turned out, the panoramic approach was commercially unsuccessful. George Davison, the Kodak representative in England, had, by way of experiment, distributed new makes of camera to innovative photographers. Davison took pictures with the new apparatus himself, as did Frank Meadow Sutcliffe, the Whitby documentarist. Exposed film was returned to Kodak head-quarters and contact prints made. These were pasted into loose-leaf folders and kept for future reference. They remain more or less undisturbed in the Kodak collection, and amount to one of the most interesting caches in the history of the medium.

If the cameras of 1889, with their 100-exposure rolls of film, were meant for long-distance travellers, those of the late 1890s presuppose an interest in cities

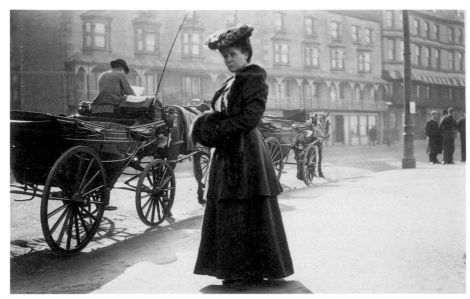

George Davison
Mrs Davison, March 1906.
Contact print on printing-out paper,
taken with a Kodak 4A folding camera.
102mm × 159mm
(from the Collection of the
National Museum of Photography,
Film & Television)

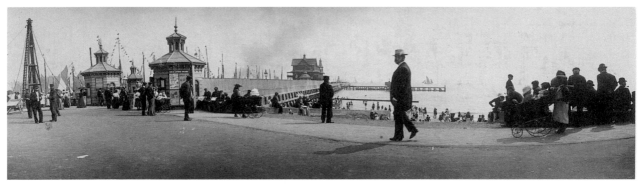

George Davison. *Promenade, Rhyl, c.* 1902. Contact print on printing-out paper, taken with a Kodak no. 4 Panoram (the second type of panoramic camera manufactured by Kodak. 83mm × 286mm (from the Collection of the National Museum of Photography, Film & Television)

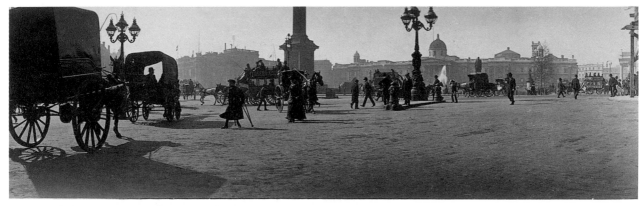

Anon. Kodak trial picture, *c.* 1902. Contact print on printing-out paper. 51mm × 171mm
(from the Collection of the National Museum of Photography, Film & Television)

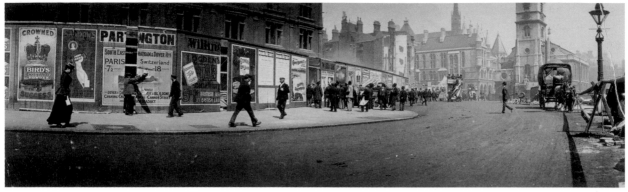

Anon
Kodak trial picture, *c.* 1902.
Contact print on printing-out
paper. 51mm × 171mm
(from the Collection of the
National Museum of Photography,
Film & Television)

and in promenades at spas and coastal resorts. The city had been on photography's agenda before, in the late 1850s when the Anthony brothers had photographed New York City, yet in 1859 there had been little interest in citizens as persons who might be encountered. Photographing from first-floor balconies, the Anthonys had represented the street as infinity and as a transcendental destination or goal which made sense of contingencies and of the crowd. The new panoramic cameras of the late 1890s seem, by contrast, to have been intended for use at ground level, amongst the crowds at London's Trafalgar Square, Piccadilly Circus or Leicester Square. Using tripods, Kodak's trial panoramists recorded passing traffic on ordinary days. London's streets and squares were crossed by horse-drawn omnibuses and by pedestrians of all sorts, who were sufficiently individualized not to constitute a crowd. Builders and workers dug up the streets, along the Strand in particular, and sites were screened by billboards announcing performances and brandnames of all sorts. Politically this photography is a liberal art, for it adheres (knowingly or unknowingly) to the idea that other people are distinct individuals with their signatures, which might be a way of wearing a coat or a hat or of just sauntering. The identity of the city also stems from these chance encounters, rather than from major monuments and spires (which are relegated to the background by the panoramic format), and the city is represented as a place equal to and sometimes even inferior in interest to the foreground's saunterers. London, of course, may have been the last major city in which a photography of this kind was possible, for the streets of New York City were canyons orientated towards infinity, and Paris had been re-styled to the same effect. Only London, with its archaic Circuses and Squares with their low and improvised frontages, still provided a setting and a stage for the singular citizen.

The panoramic format seems to have been imbued with its own liberal values. Squares, rectangles and the circles, photography's more compact formats, lent themselves, by contrast, to emphases, presenting outstanding figures and deep spaces. None of the conventional formats could include enough of the world to function as anything other than fragments; and as fragments they suggested that there was a hidden or implicit scheme of things, known only to the photographer

and his agents. There is always the question in a conventional photograph of what is happening in the rest of the world beyond the frame, and why this particular extract has been taken rather than another. Panoramas, on the other hand, give an impression of plenitude. Rather than making a mark, they invite inspection across the breadth of the picture and imply that one item is as deserving of attention as any other. In the 1950s the great Czech photographer, Josef Sudek, sought out and used a Kodak panoramic camera of 1900 to undertake a new photographic study of Prague. What Sudek's exact intentions were may never be known, but they seem to be implied by the look of a set of pictures which privilege foreground over background, or the artist's immediate circumstances (made up of tracks, cobblestones and clumps of grass) over the city's monuments. Sudek classified himself, that is to say, as a pedestrian and as a relative outsider in respect to the city which stands as a symbol of culture and civilization. Sudek may have been considering his position in the recently installed Communist polity of Czechoslovakia, but in the 1890s, amongst Davison and his contemporaries, there was no such overt need to take that kind of stance and to establish a distance. However, this does appear to have been an era in which individual autonomy was at issue to some degree. One of the major genres of the period involved *petits métiers*, hawkers and street-sellers of newspapers, matches, balloons and ice-cream. Eugène Atget, who was to become one of the most admired of all modernist photographers in the 1930s (after his death), recorded just such characters in Paris in around 1900. The *petits métiers* was a long-standing genre stretching back to the seventeenth century at least, but hawkers counted in 1900 largely because of the way in which they commanded a modicum of space in the street. Principally they cried out, and, for a while, stood for a personal place in the busy life of the metropolis.

If the Kodak panoramas are to be understood, there is no better place to turn than to Joyce's Dublin, the site of *Ulysses*. The panoramas might have been made with *Ulysses* in mind: the title itself appears on the advertising board of a charabanc in one of the Kodak panoramas, and London's streets feature any number of Dublinesque pedestrians, such as the man in the mackintosh, one of Joyce's recurrent background figures. James Joyce envisaged *Ulysses* in around 1909 and wrote it in Trieste-Zurich-Paris between 1914 and 1921. It is an account of a day in Dublin in 1904, seen partly through the eyes of Leopold Bloom, a Dublin Jew with interests in 'Snapshot photography, comparative study of religions, folklore relative to various amatory and superstitious practices, contemplation of the celestial constellations' (from *Ithaca*, the seventeenth of the book's 18 sections). A fair proportion of *Ulysses* takes place on foot along the streets of the city, most notably in *Wandering Rocks*, the tenth section: 'Almidano Artifoni walked past Holles Street, past Sewell's yard. Behind him Cashel Boyle O'Connor Fitzmaurice Tisdall Farrell, with stickumbrelladustcoat dangling, shunned the lamp before Mr Law Smith's house, and, crossing, walked along Merrion Square. Distantly

behind him a blind strippling tapped his way by the wall of College Park.' This city recalled elsewhere in *Ulysses* is rich in proper names, signs in themselves of an achieved identity. It seems at times as if Bloom/Joyce knew or knew of the whole of the city by name, with only 'the blind strippling' and 'the man in the mackintosh' as representatives of a more shadowy mysterious otherness. *Ulysses* is compatible with photography at almost every level. It is, in addition to everything else, a book of local history, dating back as far as day-to-day memory would stretch and into the 1880s at least. Photography, like the Dubliners, kept its own accounts, and was careful to give everyone credit, listing names and distinctions in the excessive way familiar throughout *Ulysses*. In 1890, for instance, when E. W. Maunder, FRAS, gave an informative talk to the Royal Photographic Society on the 'Application of Photography to Astronomy' (published in *The Photographic Journal*, 23 January 1891), he showed a group photograph of and listed all the 55 participants in the Paris astronomy congress of 1887. The photographic world kept very strict accounts and, during the 1890s in particular, raked over the history of the medium giving credit wherever it was due. This sense of a united community with a well-known, detailed history began to fade during the first decade of the twentieth century, at about the time that Joyce was beginning to think of *Ulysses*. Photography's own homage to the age of the proper name was written later, by Helmut and Alison Gernsheim, and published in 1955 as *The History of Photography*. For the record it ought also to be said that Joyce was just as interested as Mallarmé and Muybridge in delaying and stopping time, by dint of repetitions and inversions.

'Cockney Snaps'

Paul Martin forms a sub-section in this history of instantaneous and street photography. In 1939 Martin (1864–1942) wrote a memoir called *Victorian Snapshots*, which throws some light on the era of the 1890s. He began his career as a wood-engraver in the 1880s, for the *Illustrated London News*, in a business which would be destroyed after 1900 by the development of cross-line screen printing. He took up photography in 1883, using a Meritoire camera, manufactured by the firm of J. Lancaster in Birmingham. (In the 1880s what was called a 'camera epidemic' took place, with a lot of new models being introduced every season.) Then in 1886 he replaced the quarter-plate Meritoire with a half-plate Instantograph made by the same company. In the late 1880s Martin took up art photography, using a whole plate camera and working under the influence of George Davison, the man who became Kodak's agent in Britain. Quarter-plate pictures measured approximately 9×12 cm, half-plate 12×16, and whole-plate 17×22, although these sizes varied from country to country. Art photography of the kind practised in London by Davison and Colonel Gale, Martin's exemplars, was naturalistic: it presented country people at rest in the style of the French painter Jean-Francois Millet.

Paul Martin
*Children Playing,
Hampstead Heath*,
1898. Contact print
on printing-out paper.
121mm × 165mm
(from the Collection
of the National
Museum of
Photography,
Film & Television)

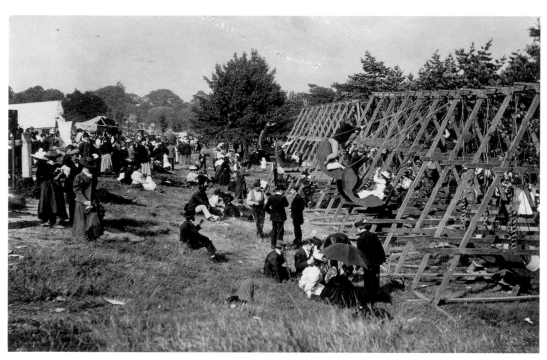

Paul Martin
*Fairground,
Hampstead Heath*,
1898. Contact print
on printing-out paper.
95mm × 152mm
(from the Collection
of the National
Museum of
Photography,
Film & Television)

71

Paul Martin
Shooting Booth, Hampstead Heath 1898.
Contact print on printing-out paper.
79mm × 79mm
(from the Collection of the National
Museum of Photography, Film & Television)

Martin, however, was affected in 1890 by the craze for instantaneous or detective photography, and bought a Facile hand camera, a box measuring 8 × 6 × 11 inches, which could be loaded with 12 quarter-plates. Martin adapted the camera to his own requirements and especially for use in the street, going on to take pictures by night on the Thames Embankment. Having made his reputation as an instantaneous photographer he was asked by George Davison to test the new Kodak lightweight cameras, a Falcon No. 2 and a half-plate camera. He tried them out in Victoria Park and on Hampstead Heath on a Bank Holiday. His reports are rich in spontaneous detail and seem to require little commentary. Martin himself says little about them dubbing them simply 'Cockney snaps'. Printed in *Victorian Snapshots*, they look like nothing so much as innocent precursors of the reportage photography of the 1930s. However, it must be remembered that Martin was by trade a wood-engraver and so his early years had been occupied by a lot of close work with directed light and an eyeglass. This experience seems to have influenced his 'Cockney snaps', for many of them contain incidents which have to be looked for and detected. They are lens pictures, made up of nothing but snatched moments: exchanged glances, sub-groups of two and three engrossed in games and conversations. They show people clearly enough, but have been taken at a point when people still have to be comprehended as a mass. Martin seems to take it for granted that his Cockneys are distinct, individually bored and intrigued by the distractions on offer on Hampstead Heath and at the coastal resorts, such as Great Yarmouth, where he also photographed. By 1939, when anyone's business was everyone else's, this representation of the private sphere within the public must have looked remarkable.

Martin's were, in the language of the time, instantaneous pictures. By the 1930s they may have been classified in companionable terms, as a kind of reportage, but in its heyday in the 1890s, when it was still new, the instantaneous mode had something of the outlandish about it. In his comprehensive *Dictionary of Photography*

E.J. Wall includes several long lists under the general heading of 'Instantaneous Photography', culminating with one of 13 entries relating to distances and shutter speeds; it begins with 'standing children or half-length men with heads ¾ inch from top to chin' and ends with 'express train, balloon, storm waves, greyhound coursing, skater, racehorse, dynamite explosion'. Such lists of subjects suitable for instantaneous photography were commonplace in the photographic literature of the period, and constitute a vision of the world in functional and impersonal terms: they could encompass 'laughing children, dogs and cats, cattle feeding', or any kind of object or being as long as it was in a certain kind of motion. Photography, from the outset, gave rise to such absurd and brutal classifications, which are particular to the medium and relate to nothing other than its performance characteristics. The subject of the era of 'Cockney snaps' merely had to move, irrespective of any place it might have in the grand order of things and irrespective too of any meaning it might have in the spiritual life of the 'artist'. A man walking in a Kodak circular snapshot of 1890 is just that, a figure stripped of all meaningful supplements and personal nuances. Photography, for a brief moment, achieved a quality of disinterestedness which would be admired by the modernists of the 1920s, by Francis Picabia, for example, who introduced the magazine *391* in October 1924 as the *Journal de l'Instantanéisme*. According to Picabia's sub-title the instantaneist was a being who was 'exceptional, cynical and indecent'. What Dada meant by *instantanéisme* can be grasped by looking at the very earliest snapshots with their quite impersonal dedication to humdrum appearances. The purest *instantanéisme* dates from 1889 and it continued into the early 1890s; its liberating, value-free mentality can be identified in the earliest of Kodak's experimental snapshots.

Photography evolved in the short term and what contemporaries thought of as an experimental phase (calotype, stereo, instantaneous) always turned out to be a high-water mark. The technique in question was either bypassed or used to perfection by an eccentric successor: Josef Sudek working in Prague in the 1950s with a procedure devised in the late 1890s is the most outstanding case in point. In Britain the main beneficiary of the 'camera epidemic' was Alfred Hind Robinson (1864–1950), a Yorkshire gentleman who had an estate at Hackness and who lived at Scarborough. In 1903 he bought a Kodak No. 4 Panoram Camera, which used No. 103 film (five negatives at 10 × 3 inches each). In 1908 he contributed photographs to J.S. Fletcher's book, *The Enchanting North*, published by Eveleigh and North. Later he made topographical pictures for sale to railway companies, to be used to decorate passenger carriages. Robinson also photographed golf courses. Golf has played no part in photography history to date, but it was and remains a site-specific game compatible with the kind of values implicit in the new photographic equipment and media of the 1890s. Golf was at odds with the calibrated ethics and aesthetics of the modern era (1920s and 1930s), and only returned to the centre of the stage in the liberal climate of American culture after 1939–45.

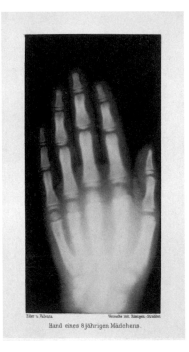

Josef M. Eder & E. Valenta
Hand of an 8-year-old girl. Photogravure, 1896,
taken from the original X-ray. 203mm × 114mm
(from the Collection of the National Museum
of Photography, Film & Television)

X-ray or 'New' Photography

X-rays

Also called radiography in the
1890s. Electricity passed through
a vacuum tube results in radiations
from the cathode (negative pole),
which seem to be reflected from
the anode (positive pole). These
cathode rays were re-named
X-rays by Professor Röntgen
of Würzburg in 1895. Röntgen
noticed that these radiations
affected gelatino-bromide film
and were capable of passing
through opaque objects. X-ray
or 'new' photography did not
need a camera. It was sufficient
to wrap film in black paper
and to place the object to be
photographed between it and
the source of the rays. It became
a dangerous hobby for some
years.

Instantaneity was as much part of photography's agenda as colour. Both had been foreseen and planned for. X-ray or 'new' photography, on the other hand, seems to have come out of the blue in 1895, and to have created a sensation. It was discovered more or less by accident by a German scientist, Professor Röntgen of Würzburg: 'Then with those Röntgen rays searchlight you could,' reflected Joyce's L. Bloom as he 'walked towards Dawson Street' in the *Lestrygonians* section of *Ulysses*, wondering if there was spinach stuck between his teeth. Röntgen's rays, which he called X-rays, entered the public imagination. In 1896 Hall-Edwards, a British scientist, in a talk entitled 'Photography by the Röntgen Rays', up to date, published in *The Photographic Journal* of 30 January 1897, referred to 'photographic friends sick of the subject, whilst others have worked themselves into a state bordering upon lunacy from the constant viewing of portions of their own and their friends' skeletons'. In another article in *The Photographic Journal*, 'Five Years' Work with the X Rays', published on 29 June 1903, William Webster remarked on the 'curative' properties of X-rays: 'I had noticed the action in January, 1897, on my own skin, for the nails came off my hand, and ever since that time my skin has been as if I had lived in India for a considerable time; one curious result was and is that gnats and mosquitoes no longer bit where the rays acted.' X-rays were like cathode rays; they were radiations given off from the cathode (negative pole, from the Greek *kathodos*, meaning descent) in a highly exhausted vacuum tube during the discharge of electricity. Röntgen noticed that the vacuum tube gave off

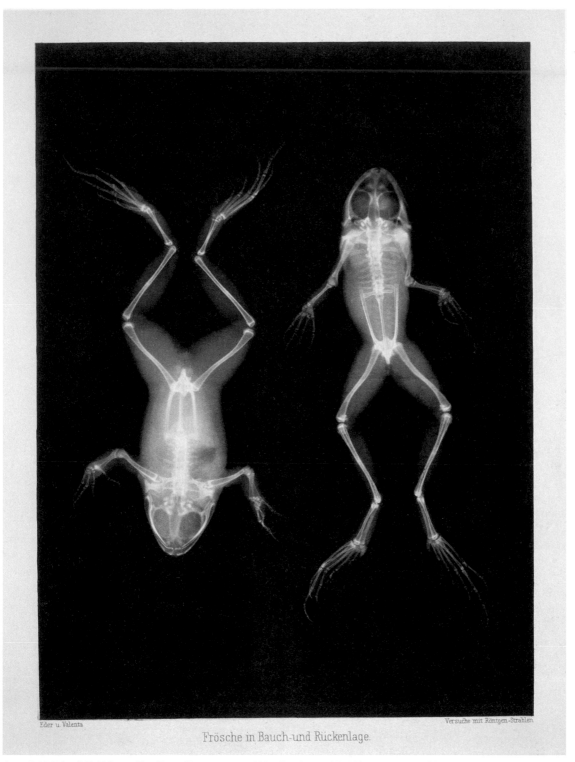

Eder u. Valenta

Versuche mit Röntgen-Strahlen.

Frösche in Bauch-und Rückenlage.

Joseph M. Eder & E. Valenta. *Two Frogs*. Photogravure, 1896, taken from original X-ray. 254mm × 190mm
(from the Collection of the National Museum of Photography, Film & Television)

rays which could penetrate opaque materials and produce outline photographs of hidden elements, such as the bones within a hand. X-rays were, like infra-red, a kind of invisible light, and provided evidence that there was a scheme of things not geared to human vision. The vacuum tubes in question had been in use for some time, and in England were known as Crookes' tubes, after the experimenter Professor Crookes. They were used for experiments with fluorescence, or light generated in a vacuum. Although Röntgen is usually given the credit, there were others involved: a Professor Hertz who identified cathode rays, and a scientist, Lenard, from Bonn, who in 1894 published information on 'shadowgraphs' obtained from cathode rays. This 'new' photography became a popular craze in 1896, but it was not long before its useful medical applications were recognized. No one knew for sure what X-rays were: ultra-violet light vibrating a million times faster than ordinary light, or 'the missing longitudinal waves in the ether' (from Alfred T. Story writing in *The Story of Photography*, published in London in about 1900). Crookes, Röntgen and their contemporaries had identified something full of promise, which would lead to some extraordinary discoveries. Experiments with the Crookes' tube had been with electricity in attenuated gases, called 'radiant matter', all on 'that shadowy borderland where matter and force merge into one' (from Hall-Edwards' article of 30 January 1897). E.J. Wall provided practical details in his *Dictionary of Photography* on the cost of vacuum tubes and fluorescent screens, for there were many would-be experimenters. Dr J.M. Eder, who along with E. Valenta, made the pictures on show here, not only wrote an important history of photography himself (published in the 1930s) but was also a chemist of note who invented chloro-bromide gelatine paper in 1883, and perfected orthochromatic film in 1884.

X-rays contributed to a sense, widespread in the 1890s, that there was more to actuality than met they eye, and that this supplementary quality could be picked up either by special equipment or by sensibilities finely attuned. Many of the shadowy art photographs of the late 1890s and early 1900s may depict little more than vegetation and reflections in water but they look like 'shadowgraphs', as if the photographer had the power to see into nature. Eder's portfolio is also interesting as an inventory (chameleon, flatfish, lizard, rat, frog, foot of a 17-year-old, hand of an eight-year-old girl), even if it is only of objects large enough to be X-rayed and which might have an internal structure which would show up on the plate. Röntgen himself listed this kind of material in his announcement of 1895, 'On a New Kind of Rays': published in *The Photographic Journal* on 31 January 1896, 'A shadow of the bones of a hand, of a wire wound upon a bobbin, of a set of weights in a box, of a compass card and needle completely enclosed.'

Although the X-ray craze passed, it had made a difference in photography. Fox Talbot's *Haystack* of 1844 may have signalled, with respect to the preacher in Isaiah, that all flesh was grass, and belonged to an order of things which passed away. X-ray photography reinforced that conclusion, remarking further on the

evanescence of flesh. It altered, too, what might be called the symbols of photography. Since 1839 these symbols had been mainly animal and vegetable, and specifically albumen and gelatine. Metallic daguerreotypes had been an exception. Then all at once the new X-ray photography changed the idiom to include rays and 'radiant matter', together with metals: aluminium, which was easily penetrated by the rays, through to lead, which offered most resistance. The rhetoric of this new photography was harsh, at least in comparison to what had gone before, and its preferred topics, bullets and needles in flesh, and fractured bones, foretold 1914–18. Interestingly, it coincided with the last stages in the development of colour photography, one of the most benign moments in the history of the medium and attentive to the look of things, the mere beauty of flesh as grass.

The idea of the X-ray was important to successors; it allowed them to reconsider art and its metaphysical potential. This is, for example, Giorgio de Chirico reflecting on the possibilities of art in an article *On Metaphysical Art*, published in the Roman periodical *Valori Plastici* in April–May 1919: 'One can deduce and conclude that every object has two aspects: one current one which we see nearly always and which is seen by men in general, and the other which is spectral and metaphysical and seen only by rare individuals in moments of clairvoyance and metaphysical abstraction, just as certain hidden bodies formed of materials that are impenetrable to the sun's rays only appear under the power of artificial lights, which could, for example, be X-rays.' De Chirico may well have had his ideas without benefit of Röntgen, but all the same the idea of the X-ray was a powerful one, especially with respect to the unknown and to the secret side of things.

Discovering Colour

Colour had been high on photography's wish list from the very beginning, but it had turned into an intractable problem which was only solved, after a fashion, with the appearance of the Autochrome process, developed by the Lumière brothers in France and announced in 1907. Colour had many pioneers; German, British, French and American. It had an inventor ahead of his time: a Dr Gabriel Lippman, who took the first authentic colour photograph in 1891, but whose process was difficult and had no commercial application. It had, too, a tragic hero in Ducos du Hauron, a French pianist who made several important discoveries, also ahead of their time, in connection with a subtractive three-colour process. Ducos du Hauron died in poverty in 1920, having seen others capitalize on his inventions.

Workers in colour in about 1900 thought in terms of the difference between additive and subtractive colour. In each case, it was necessary to secure three coloured transparencies. If the three were superimposed and a light shone through them, as in a slide, the result was a composite (additive). By the subtractive method prints were taken from superimposed single-colour negatives, and those colours not desired were removed. Otto Pfenninger, a British pioneer working in

Colour photography

The bringing of colour into photography is a great and usually untold story, because of its challenging combination of chemistry, physics and physiology. Ducos du Hauron, a French pianist and inventor, was the first to undertake a serious study of colour and its application in photography. The first successful colour picture, however, was taken by a French scientist, Gabriel Lippman, in 1891. Lippman used something called the interference method, founded on the theory of stationary waves (coloured light, that is, which vibrated to different wavelengths). The future lay with the three colour sensation process, based on our optic susceptibility to red, blue and green. The additive process meant the superimposition of three lights (red, green and blue-violet). In the subtractive process, three pigments absorb all colours except their own, which they reflect. The Lumière brothers of Lyons, who introduced the Autochrome process in 1907, built on the work of both Lippman and du Hauron.

Anon
Girl Reading, 1912.
Paget process.
165mm × 121mm
(from the Collection of the
National Museum of
Photography, Film & Television)

Brighton, describes this distinction between additive and subtractive processes in a book of 1921, called *Byepaths of Colour Photography*, published under the pseudonym of O. Reg. Pfenninger was interested in the subtractive method and the making of colour negatives. The negatives had to be blue, pink and yellow, the subtractive primaries, and one problem he faced was that the colours each had very different exposure times. If they were to be taken simultaneously in the same camera, in three different chambers, sensitizers had to be developed to equalize the exposure times. Pfenninger's cameras also had complex internal systems of lenses, filters and transparent mirrors and, although he succeeded in making photographs in colour in 1906, his process was too intricate to have any commercial application.

Pfenninger referred to the Autochrome process as semi-additive. It was announced by August and Louis Lumière in 1904, and put on the market under the brand name 'Autochrome' in 1907. Autochromes were coloured transparencies on glass, and had to be projected or seen in a viewer. Like daguerreotypes they were unique positives. The Lumières' announcements were long-winded, although the procedure sounded simple enough. Dyed starch grains were applied to glass plates, and then flattened under pressure and coated with a panchromatic emulsion. It was the refinement of this emulsion which delayed the launch of the product. The starch grains were dyed green, violet and orange (since the additive primaries were different to the subtractive primaries, as Pfenninger was careful to point out). On exposure these dyed grains filtered out certain colours, allowing others to register on the panchromatic backing. Autochromes were developed as black-

Isochromatic photography

From the Greek terms for equal colouring. One of the great problems faced by manufacturers was to make a black and white film coherent with respect to colour. Ordinary plates were over-sensitive to blue and not sensitive enough to green, yellow, orange and orange red. A lot of experimentation in the 1890s was devoted to overcoming these difficulties. Compensatory dyes were added to plates: eosin, a coal-tar dye and quinoline blues and reds. The experimentation involved resulted in the invention of colour photography in 1906–7. Isochromatic plates were sensitive to gas and lamp light.

Anon
Sempre Avanti: Italian lake scene
*c.*1910. Stereo autochrome.
Dimensions (whole object):
40mm × 120mm
(from the Collection of the
National Museum of Photography,
Film & Television)

and-white film, and then treated chemically to produce coloured positives.

The Lumières' account of their process was published in *The Photographic Journal* in July 1904. They stressed some of the difficulties they had encountered in getting the starch coating sufficiently thin and in preparing suitable varnishes. The starch grains had to be very small indeed to form a screen in which 'each square millimetre of surface represents two or three thousand small elementary screens of orange, green and violet'. When the Autochrome process is introduced in the technical glossaries of major catalogues, it seems usually straightforward, just another instance of experimental ingenuity of the kind which has always characterized photography. However, this is a wrong impression, for the Lumières were big business and probably the only unit in the world capable of committing resources on a large scale to the refinement of a process such as this. The business had been founded in Lyons in 1883 and, by the time the Autochrome was announced, its factories covered a 10-acre site. The company's reputation for research continued through the 1890s and it became known for 'new photographic developing agents, the chemistry of development and processes connected therewith, also with the causes of the insolubility of gelatine under the action of chromic acid and metallic bichromates by light or spontaneously in darkness, as well as by other chemical agents, reduction and intensification of photographic negatives, toning and fixing agents, etc.', all according to an article by Major-General J. Waterhouse published in March 1909 in *The Photographic Journal*. The Lumières' investment in research and development anticipates the way the photographic industry was to develop in Germany and the USA from the 1920s onwards. Henceforth improvements would be refined over the long term by research teams, and the old-fashioned inventor, as exemplified by Pfenninger and his heroic precursor Ducos du Hauron, would become a figure consigned to the romantic past.

In the summer of 1907 it looked as if the Autochrome process would carry all before it, and that monochrome photography would become an outdated practice. Alfred Stieglitz, who was at the time the most significant artist working in photography, witnessed the announcement of the process at the Photo-Club de Paris in June 1907, and that summer he put it to the test at Tutzing in Bavaria, in the company of Edward Steichen, Heinrich Kühn and Frank Eugene. In September Stieglitz exhibited his own Autochromes at his gallery in New York, along with some by Steichen and Alvin Langdon Coburn. There was a plan to publish a special autochrome supplement to Stieglitz's magazine *Camera Work*, but that came to nothing. In 1909, 40 autochromes were exhibited at the International Exhibition of Pictorial Photography in New York, but after this brave start the process made relatively little headway, although it continued in use well into the 1930s. There were few star photographers associated with it, although it was used by Jacques-Henri Lartigue in France. Léon Gimpel is perhaps the best-known practitioner, and his Autochromes appear as late as 1936 in *L'Illustration*, the important French culture magazine. Gimpel's prints from Autochromes show the landscape oddly transformed, as if it has been dusted with coloured chalk, with everything, from skies to hillsides, made from the same powdery substance. Autochromes took up to 40 times longer to expose than monochromes, which accounts for their being concentrated on landscape. And yet Gimpel also photographed flocks of sheep in his travels for *L'Illustration*, implying that the process can't have been that unwieldy.

The truth is that Autochromes were ethically inopportune, and increasingly regarded as such as modernist ideas took hold in the 1920s and later. They represented the luxuriant world, rich in and even heavy with atmosphere, and they were at their best with flowers, fruit, surfaces and textures. Colour's subject was hedonism, in support of an idea of humanity as warm-blooded rather than sharp-minded. In the era of ideological mobilisation which followed on the unsuccessful resolution of the Great War, the Touring Club aesthetics of photographers such as Gimpel looked out of keeping, naïvely self-indulgent.

The aesthetics of the Autochrome practitioners were as personal and liberal as those of the panoramists of the 1890s. They understood the individual, however, less as a cultural creature, in the style of Joyce's Bloom musing and reading the hoardings and the headlines, than as a sentient being subject to the pleasures of atmosphere, the aromas of flowers. They were at one, for instance, with the northern architecture of the Edwardian era which was preoccupied with bodily comfort; it was an architecture of fireplaces, easy chairs and pools of light around billiard tables. The aesthetic wasn't broken by the Great War which, in its own perverse way, underlined the value of creature comforts; but it was certainly at odds with the new collectivisit ideologies of the 1920s, all of which were wary of the kind of physical satisfactions which were advertised by the Autochrome process.

Colour film

Kodachrome was invented by Leopold Mannes and Leopold Godowsky and then acquired and perfected by Eastman Kodak during the 1950s. It is a film with three emulsion layers separated by fine membranes. The top layer records the blue part of the image, the middle the green and the lowest the red. Dufaycolor was an alternative to Kodachrome during the 1950s, but less successful. It used a single panchromatic emulsion layer with a greasy ink resin printed on a dyed base. Dufaycolor transparencies were made up of a geometrical mosaic of blue and green squares separated by red lines. The colour elements were tiny. Dufaycolor transparencies were positives which could be projected as well as printed, but the printing process was quite difficult to accomplish.

Otto Pfenninger
Figures around Boat,
August 1906. Tri-colour print.
62mm × 87mm
(courtesy of the Royal
Photographic Society, Bath)

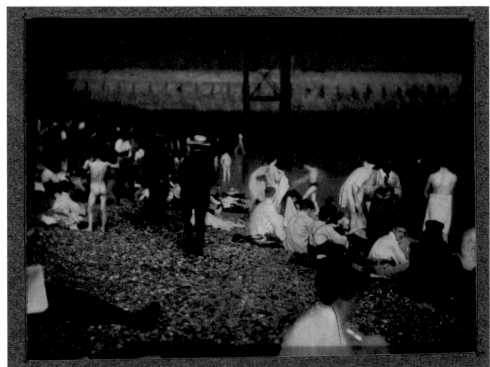

Otto Pfenninger
*Figures and Nude Boy with
Supports of Pier in Distance*,
August 1906. Tri-colour print.
64mm × 86mm
(courtesy of the Royal
Photographic Society, Bath)

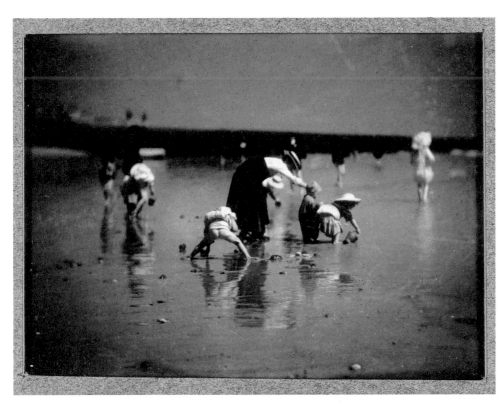

Otto Pfenninger
Mother and Children Paddling,
16 June 1906. Tri-colour print.
134mm × 173mm
(courtesy of the Royal
Photographic Society, Bath)

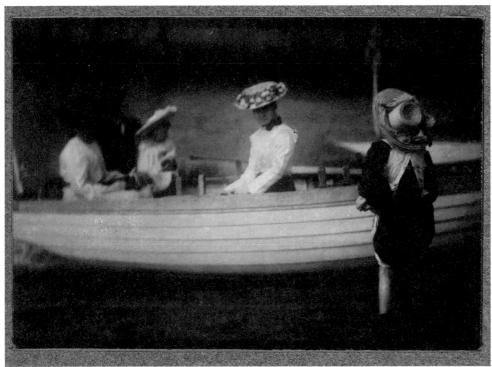

Otto Pfenninger
Women and Child in Boat,
August 1906. Tri-colour print.
59mm × 84mm
(courtesy of the Royal
Photographic Society, Bath)

Anon
Rocket Invention Tests,
Dumer-See, Germany, April 1931.
Silver gelatin print. 254mm × 204mm
(from the Collection of the
National Museum of Photography,
Film & Television)

Wirephotos

While the Autochrome was being perfected by the Lumières, other inventors were preoccupied by the problem of the transmission of pictures via wire and radio. This was a relatively new concern, which first emerged in the 1880s and was taken up in the 1890s. Like the celestial photographers of the period, the wirephoto pioneers tacitly assumed a comity of nations, or at least good enough relations for it to be possible to send pictures from Paris to Berlin or from London to Paris. World Wars and ideological stand-offs restricted the use of wirephotography for several decades, and it was not until the mid-1960s and the Vietnam War that it came into its own. In 1891 the German inventor Paul Eduard Liesegang wrote an article, published in Düsseldorf, on the problem of the electrical transmission of pictures. At around this time an American inventor in Cleveland named Amstutz, patented an artograph, a machine for transmitting and receiving pictures. The artograph worked like a gramophone record, with the picture transmitted by means of a needle passing over a photographic surface which had been processed in low relief; carbon prints were ideal for this. Pictures were to be received onto celluloid or chemically prepared paper. Interestingly nothing seems to have come of Amstutz's patent, and he must take his place with all those others who patented in vain. Contemporaries remarked on the surveillance potential of the new medium. In the *British and Colonial Printer and Stationer* a writer imagined the scene where 'a noted criminal escapes from the New York police. Almost as swiftly as the message recording his escape can be transmitted, a photograph of the criminal

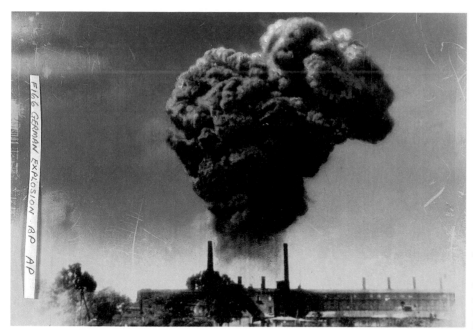

Anon
Munitions Factory Explosion at Wittenberg, Prussia, June 1935. Wirephoto. 178mm × 254mm (from the Collection of the National Museum of Photography, Film & Television)

can be sent, and the police in any city in the country can be on the look-out for the criminal' (quoted in Albert T. Story's *The Story of Photography, c.* 1900). In April 1908 T. Thorne Baker gave a full account in *The Photographic Journal* of developments in photo-telegraphy, and he also remarked on its use in surveillance. The German police, it seems, had a plan to install what were then called Korn instruments (after another major pioneer) in police stations. Baker remarked that, 'in the present condition of the system the adoption of such a plan would be likely to increase the possibilities of wrongful arrests'.

Liesegang's notes on *das electrische Fernsehen* referred to selenium becoming more conductive under the action of light. This quality in selenium was central to Professor Arthur Korn's work on 'tele-vision' undertaken between 1902 and 1907. The image to be transmitted, which was mounted on a flexible celluloid base, was wrapped around a cylinder and scanned by a beam of light (from a Nernst lamp). This beam was then deflected via a prism onto a primary selenium cell, subject to an electrical current which fluctuated according to the intensity of the light given off by the surface of the photo. Once transmitted, the fluctuating electrical current was received by a cathode ray tube and relayed onto a film as a negative. Korn wirephotos were made up of 144 lines 2mm apart, and took 12 minutes to transmit. In 1908 there were, according to T. Thorne Baker, four stations fitted with Korn's apparatus, at Berlin, Munich, Paris and London. The first transmission of a wirephoto took place between Munich and Nuremberg in 1904. Meanwhile in France Edouard Belin was trying to perfect *la téléphotographie* along the more mechanical lines suggested by Amstutz of Cleveland. Belin used

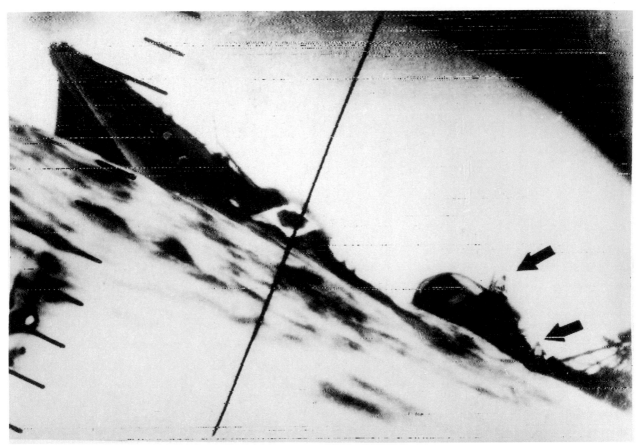

Anon
*Amazing Periscope Photograph
of Sinking Japanese Destroyer,*
July 1942. Radiophoto.
204mm × 254mm
(from the Collection of the
National Museum of Photography,
Film & Television)

low-relief carbon photographs mounted on a drum and scanned by an arm with a sapphire stylus. He persevered with his experiments and in 1926 pioneered a process including a photo-electric bulb which was applied directly to the photograph and was able to convert light intensities immediately into electrical pulses. Portable transmitters, or belinographs, came into use in the 1930s, enabling photographers to report almost without delay from news zones throughout the world. Not that very much of this kind of reporting took place, for the totalitarian regimes were wary of reports which might show them in a poor light. Nonetheless, wirephoto genres did develop: among them traffic and rail accidents, in which rescue efforts by the emergency services were featured. The heyday of the wirephoto was Vietnam when agencies all over the world were supplied with action pictures on a daily basis, partly in response to the competition of differing news media. Because of the poor quality of wirephoto prints, many were hand-rectified and toned in white and grey before publication. These crude 'painted pictures' constitute photography's own brand of Neo-Expressionism, well in advance of the 'real' thing developed by German painters in the 1970s.

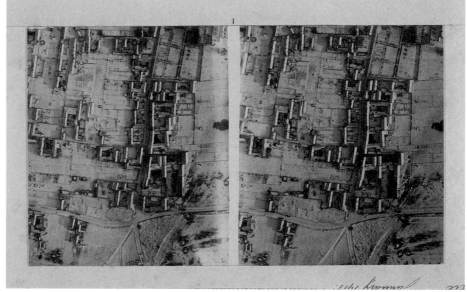

**The Royal Flying Corps.,
59th Squadron**
Dainville, near Arras, France, January
1918. Bromide stereo.
Dimensions (each image):
71mm × 122mm
(courtesy of the Royal
Photographic Society, Bath)

Aerial pictures

Although new formats continued to emerge, they were fewer and further between than before. The next outright novelty was television which appeared in the 1950s. Between the Great War and the arrival of television, photography was committed to an ideal of transparency in which pictures provided trustworthy reports on matters of inportance. The one significant innovation of the Great War itself was aerial photography, pioneered mainly for the benefit of artillery and carried out from balloons in the early stages of the War. Early aerial photographs showed the earth obliquely, and were difficult to read. The use of aircraft later in the War meant that pictures could be taken directly from above, allowing more accurate calculations than before. Aerial photography may only have used existing technologies but it made a difference to how the earth was thought about. The battlefields of France, as pictured in 1917–18, are made up of field patterns traversed by a pock-marked front line; and they recall nothing so much as the moonscapes of the 1870s, photographed from plaster models by Nasmyth. This was the first time that the earth had been visualized as a planet at least on a day-to-day basis. Viewers were henceforth able to think of the great campaigns of the War, conducted with terrible hardships and at ground level, from a privileged standpoint. Difficulties, aerial photography suggested, could be managed from afar, by whoever had access to the right co-ordinates. From this point on detailed knowledge of the state of affairs on the ground would have to be supplemented by a strategy. Almost all photography after 1914–18, if it was in the public domain, was structured around strategies, some of them undeclared.

Russian photography, for instance, after 1918 was orientated towards a representative view of 'the people', as was German after 1933. Photographers in the democracies had their own strategies which countered those of the totalitarians: night-time pictures of marginals in the metropolis, as taken by the Rumanian Brassaï in Paris for example, challenged the normative formats of Russia and Germany during the 1930s.

The Great War made other differences, which are easily overlooked. It was undertaken during the Edwardian era or Belle Epoque, when the dominant culture thought sentiently. The War was in an oddly perverted way a realization of this aesthetic for it took place very close to actualities, in mud and water, and was concluded as if in a grotesque parody of the era of sentience amongst the aromas of mustard gas. By 1918 the senses of the West had been sated sufficiently to ensure that the next phase, the one we think of as modernist, would be ascetic wherever possible.

The Modernist Stage

Modernism is a useful term, and, as far as photography is concerned, one without many mysteries. During the Belle Epoque (the era of the Autochrome) the receptor was a sentient being, likely to be enchanted by heat, light and the scent of flowers. An apple or an orange in 1907 was something in essence desirable and edible; whereas in the 1920s, and increasingly into the 1930s, it featured in 'modernist' art as a moveable item in an arrangement. Modernists thought in terms of room-space, less the deep space of the Renaissance than that of the theatre under a proscenium arch, and for preference something even shallower than that. Room space is central to modernist aesthetics. Under the old set-up *c.* 1907, the receptor was a solitary being confronted by a delightful ambience, to which he reacted passively. Anything transcendental about this relationship of 1907 had to be intuited, and the more gifted the artist the deeper the intuition. Although this intuitive idea of art never vanished, and even returned in force during the 1950s and 1960s, it did fade during the 1930s.

It is worth remembering that modern photography was, to some degree, a product of the cinema. The Leica, the camera most often associated with modernist photography in the 1930, had been devised around 1914 by Oscar Barnack, working for the Leitz Co of Wetzlar, as a way of making trial exposures in advance of cinematography. Since it was wasteful and expensive to shoot a scene incorrectly exposed, Barnack devised a trial camera which used 2 metres of film and took frames of 24mm × 18mm, which was the size of a movie frame. These test strips were meant to be developed and printed quickly in advance of shooting. Barnack doubled the size of the frame to 24mm × 36mm. In 1924 the Leitz factory manufactured six Leicas, and undertook production in earnest in 1925. The Leica became the preferred camera of Henri Cartier-Bresson in the 1930s, and then of

August Rumbucher jr.
*Night Driving no. 2, c.*1936.
Silver gelatin print.
178mm × 235mm
(from the Collection of the
National Museum of Photography,
Film & Television)

The Leica

The Leica camera was synonymous with reportage photography from the 1930s onwards. The Leica Model 1 was introduced in 1925. During the 1930s the Leica was improved by the addition of interchangeable lenses and a built-in range-finder, in particular. It was the smallest and lightest camera then in use: weighing around 425g and measuring 13.2 × 6.5 × 3cm. Dr Oscar Barnack, who invented the Leica, enlarged the frame size from 24 × 18mm to 24 × 36mm because on the smaller scale the film grain was too coarse to allow for enlargement. Barnack worked for the Leitz Company in Wetzlar, designing movie cameras.

August Rumbucher jr. *Night Driving no. 1, c.*1936. Silver gelatin print. 229mm × 182mm
(from the Collection of the National Museum of Photography, Film & Television)

Anon
*Street Trader Selling Candy
Sugar, New York, c.* 1933 – 4.
Silver gelatin print.
178mm × 241mm
(from the Collection
of the National Museum
of Photography,
Film & Television)

Anon
*Scrap Metal Seller, New York,
c.* 1933 – 4. Silver gelatin print.
178mm × 241mm
(from the Collection of the
National Museum of
Photography, Film & Television)

such successors as Josef Koudelka in the 1960s. Even though it was widely used in the 1930s, most experienced photo-reporters remained faithful to the older Contessa 'Nettel', a 9 cm × 12 cm camera of 1903, and to the Goerz/Anschütz, a 9 cm × 12 cm folding camera of 1893.

The Leica, although important, does not explain the theatricality typical of modernist photography. If the scene to be represented was thought of as a stage-set the photographer was, by the same token, a manager or director. Previously it had been the case that the picture was taken of a pre-existing state of affairs, but it was this natural or fatalistic attitude that had served everyone so badly in 1914–18. How much better it would be to manage events for the public and national good. Photography's ideas about management, however, rarely extended that far and usually went little further than the personal. It is easy to forget that before 1914–18 photographers had assumed a steady state of affairs, expecting there to be cultural continuities and stable governments. Stereo operatives may have toured the world, but they were reporting back to home cultures whose constancy could be taken for granted. After 1914–18 the old order was dislocated, although less because of the direct impact of the War than because of technical developments which brought about, in Germany and France especially, a flourishing weekly illustrated press. The rotogravure process made it possible to make high-quality reproductions of photographs and to print these in large numbers. Press opportunities increased disproportionately, and would-be photographers were attracted to Berlin and Paris if not from the edges of Europe at least from Hungary and Rumania. Thus much of the modernist photography carried out in Europe during the 1920s and 1930s was the work of *emigrés*, who were well aware of the provisional nature of culture, for as aliens in the metropolis they had had to learn to adapt. Experience taught them that culture was learnt, that it involved manners, cosmetics and dress. It was hard to avoid the idea that the metropolis, where all this learning took place, was best thought of as a theatre, in which streets and cafés constituted the stage.

There was also an ethical side to the room-space aesthetic. If the photographic scene was thought of as a stage with manoeuvrable properties there could be any number of productions and performances. A change of viewpoint or even an alteration in the light could make all the difference. Photographers were in control as never before, even if what they controlled amounted to a kind of board game, deploying paving stones, doorways, carts, streetlights, tramlines and many other items from the city's inventory. This acceptance of relativism was incompatible with the new fundamentalism of the era, but it was this quality which recommended it to the libertarian avant-gardes and beyond them to the liberal cultures of France, Britain and the USA.

Transparency and Touch

The modernist commitment, if Russia and Germany are excluded, was to whatever was personal and hand-made. Its preferred *dramatis personae* and metaphors were very much the same kind of street peoples who starred in 1900, except that in 1900 they had been known for their cries and their ability to command a local space in a thoroughfare whereas by 1930 they had become stall-holders in command of objects, even if the objects were no more than match-boxes and bootlaces. Modernism was committed, an example of its wishful-thinking, to a belief in individuals. Its great artists focused on small cast-lists made up of a few Parisian café-goers or American dirt-farmers down on their luck. It was as if they wanted to deny the ubiquitous masses who were coming into their inheritance in the triumphant fascist cultures of the 1930s. Perhaps photography was inherently a liberal medium, at least as defined by the new lightweight cameras, for even in the 1950s its great subject for a new generation, best represented by the peripatetic Swiss artists, Robert Frank and René Burri, was social exclusion in the burgeoning popular cultures of the era.

Photographic modernism, in its room-space years, was predicated on transparency, or on a sense of immediate access to the world and its objects. What could be more natural? Yet transparency was also a convention, fulfilling the haptic requirements of the new era. Stereo pictures in the 1860s were also notably transparent, but they were dedicated to a moment of visual awareness: to the visual apprehension of Niagara Falls, for example, thundering beyond the daring Blondin. Autochromes, on the other hand, presupposed sight as sense, in particular as aroma and taste. In contrast, the modernist vision, was based on a world of instruments, of gauges, dials, levers and handles, and it depended on an order of manipulable objects which might be put to use. For all of this clear-sightedness was a pre-requisite. If conditions were to be affected (an aim which was always on the modernist agenda), they had to be clearly, forensically visible. If you could see the wounds clearly, you could sympathize sufficiently with the victim to apprehend the culprit. This theory became so deeply engrained, that it eventually became like second nature.

In an extended memoir of 1934, entitled *People I Have Shot*, James Jarche, a British documentarist and reporter, gave a revealing account of a mission earlier in the 1930s to take pictures of Welsh coal-miners. Jarche worked for the *Daily Herald*, a daily paper with a popular bias. His intention was to win sympathy for the manual working classes, by making it possible for his readers to feel, even if just by proxy, the textures of their lives.

'We got permission to go down one of the deepest coal-mines in Wales, the name of which I deliberately withhold, owing to the controversy that arose by my taking shots by flash. For it was the first time that pictures had been taken in

James Jarche
Miners Taking a Break from Work, South Wales, June 1931. Silver gelatin contact print from glass negative. 95mm × 146mm (from the Collection of the National Museum of Photography, Film & Television)

James Jarche
Underground Haulage, South Wales, June 1931. Silver gelatin contact print from glass negative. 95mm × 146mm (from the Collection of the National Museum of Photography, Film & Television)

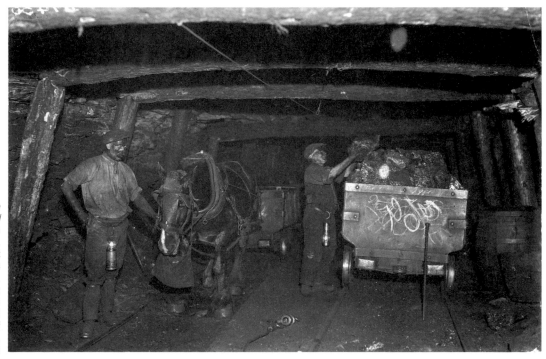

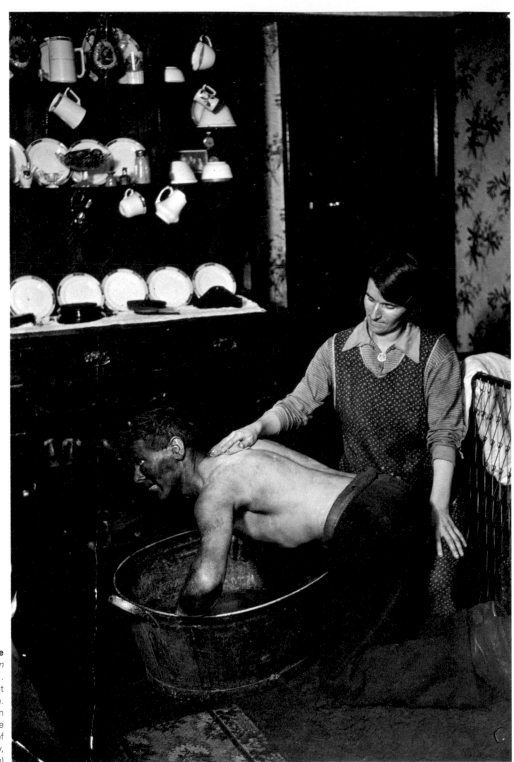

James Jarche
Miner's Wife Helping him to Wash, Wales, June 1931. Silver gelatin contact print from glass negative. 95mm × 146mm (from the Collection of the National Museum of Photography, Film & Television)

an explosive area with the new safety-light, now, however, extensively used in photography. This is not a naked flame, though it looks like one. It is shaped like an electric bulb, and is full of magnesium foil, ignited by a two volt battery, synchronised with the camera. Before permission was given me to descend the mine, I had to demonstrate with the light to experts on the surface. They themselves made experiments with it, holding the light over a gas-ring to see whether it would ignite the fumes. Of course nothing happened, and when they were satisfied as to its safety, they gave us permission to go down.

Swathed in overalls we entered a cage, and the usual trick was played on us. The cage, instead of being lowered steadily as a lift, was dropped like a plummet, at the rate of fifty miles an hour. We arrived at the bottom quite deaf, landing in an uncanny silence half a mile below the surface of the ground.

Four miners, who were attached to us, led us, stooping, crawling, scrambling through the tunnels. By the dim light of the lantern given to me, I could just see the hob-nails of the boots of the man in front of me. The smell of gas was appalling. The stench intolerable. I felt sick. I was. I staggered on.

When we reached the seam at which work was in operation, it was too low to stand upright. I put out my hand to feel the wall, longing for the feel of something tangible in that darkness. As I did so, I touched something, wet and sticky, but something filled with the warmth of life. It was a pit-pony standing by a truck.

I fixed the camera. Holding my lantern to examine the lens, I found that it was wet with condensations. This meant that we had to wait for three-quarters of an hour till the lens became accustomed to the atmosphere.

At the end of that time the foreman whispered to me, "Is everything all right?" I nodded to him. "Sure?" he insisted.

"I'm here too," I reminded him.

He didn't seem to consider my point of view at all. "It does not matter about you," he told me. "But if anything did go wrong with that light, a lot of us would go west".

Two miners with their coats in their hands held about their heads stood behind me. That, I was told, was in case there should be a flame which would form into a ball of blue fire. Unless beaten out, it would float about until sufficiently impregnated with air to make it explode. This sometimes happens when a man's pick strikes a spark, and if he is quick, as of course he is, he stamps it out before any harm is done.

There was a most tense moment before I shot the men at work.

Then the flare went up, and simultaneously I shot. There was absolute dead silence, followed by a sort of hum of relieved talk, for never had that mine expected to see itself by clear light.

From there, I went to the stables, wonderfully clean whitewashed place, with immaculate woodwork and stalls.

I was told that the racing instinct is so strong in the boys that they sometimes race

the ponies back from the seam to the stables. Of course, the way is so narrow that they cannot run abreast, but start at so many minutes' intervals and see whether the distance between them has been decreased when they reach the stable.

The riders must lie flat on their ponies' backs, and leave it to them to remember an overhand of the roof or hole in the floor.

It is naturally terribly dangerous, and the authorities are dead against the practice. But boys will be boys, and that is an aspect of pit life that no photographer is likely to get.

On my way back from the seam I came upon a lunch-party. They were sitting stripped to the waist, their sweating faces blackened with grime. To them, it was amazing that any man in his sane senses should want to shoot anything so ordinary as themselves. To me, it was appalling that human beings should have to pass their days in such surroundings.'

The best known of Jarche's mining pictures was not, however, from below ground but a miner recently returned from the pit washing in a tin bath at home assisted by his wife. In 1937 Bill Brandt took a similar picture in a miner's home at Chester-le-Street in County Durham. Jarche's prototype is quite posed, in the style of much of the documentary photography of the 1930s. He underlines the woman's action as she soaps her husband's back. Jarche, in common with the documentarists of this generation, was intent on bringing the scene tangibly to life. Hence his interest in the 'lunch-party', and his remark on the 'wet and sticky' contact with the pit-pony. After Wales he travelled to Scotland to go to sea for a day with the trawlermen of Aberdeen, and in *People I Have Shot* these too appear as a post-lunch-party enjoying tea below decks. Despite his comment that underground life was 'appalling' Jarche, with a particularly British state of mind, took full account of companionship and contentment. Darkness interested this first generation of concerned photographers, for it drew attention to the work of disclosure. Berlin's sewer-system was another favourite documentary site in the early 1930s.

Photographs were transparent or they were nothing: that was and remained the documentarists' credo. Nonetheless documentary evolved. During the 1930s and through into the 1950s the subject was contexualized: the streets children played in were thoroughly described, just as adolescents bonded against a background of juke boxes and cigarette dispensers. People were thought of as belonging to certain milieux and as being at home amongst its properties, and this was part of the liberal inheritance in documentary. Contextual documentary introduced other people in their own spaces, as if it was sufficient, as it was for a long time, simply to live and let live. That policy lost some of its urgency after 1945 and the defeat of Fascism. Documentarists then began to think of their task more positively, as one which could ensure understanding and even right wrongs. For the sake of empathy, photographers approached their subjects more closely than ever before.

As a consequence of this new nearness, context was increasingly disregarded in favour of an expressive portraiture of faces and limbs. From the 1940s onwards, documentary became expressive and even importuning, whereas formerly it had been disinterested and sometimes even playful. The audiences imagined by late documentarists were passionately interested in others' predicaments. This is one way of explaining the decline of descriptive documentary and the rise of an expressive version of 'concerned photography'.

New Motifs: the A-bomb

It is also hard to resist the idea that the collective imagination is shaped from time to time by powerful new motifs. One of the groups of images in this exhibition presents pictures of iron filings drawn into patterns by magnets and electrical currents, and they might almost represent this work of formation. Sometimes the new lodestar can be identified; and in the 1880s it was probably to be found amongst the stars, symbolized by the Great Nebula in Andromeda perhaps. In 1912 the poet Ezra Pound wrote of 'our kinship to the vital universe, to the tree and the living rock'. He cited 'the universe of fluid force, and below us the germinal universe of wood alive, of stone alive.' He might have been thinking of radioactivity, everywhere present in the rocks of the earth's surface and responsible for a 'slow but enduring form of thermal genesis' (from John Joly's *The Surface History of the Earth*, 1925). Photography, for a time took place against this background of the aeons. It was only in the modernist inter-war years that consciousness of infinity faded; and modernism may even be interpreted as a form of impatience with the aeons. The future, as sketched in by the emerging USSR, preoccupied the modernist imagination; but this projection of the future was perverted, first by the Holocaust (a complete negation of the humanist component in modernism) and secondly by the A-bomb. Photography from 1945 onwards set itself by sheer weight of production to deny memories of the Holocaust, as if extravagant evidence of human goodness could overcome the imagery of 1945. *The Family of Man*, introduced by its curators at New York's Museum of Modern Art in 1955 as 'the greatest photographic exhibition of all time, 503 pictures from 68 countries', did its best to reinstate an idea of humanity contented within its various cultures.

The A-bomb, too made its entry in 1945, and for the next two decades it was the most photographed, as well as the most lethal, of all spectacles. Constituted of the kinds of elements, uranium in particular, to which John Joly had referred in *The Surface History of the Earth*, the A-bomb was quasi-natural, as its photographs emphasized. Its radiant energy was comparable to the rising of the sun, it produced towering clouds and was able to create micro-climates of its own. The A-bomb followed the sublime tradition of discovery set by X-rays and the Great Nebula, but it was like a pastiche of that tradition. Whereas the great recently identified forces of the Victorian Age went discreetly about their formative

The Family of Man

This was a benchmark exhibition in the history of the medium. It was organized for New York's Museum of Modern Art by Edward Steichen and Wayne Miller. Steichen had been an art photographer of note at the beginning of the century, before turning to fashion in the 1920s. Miller was a documentarist and realist who joined Magnum Photos in the 1950s. The final selection was made from 10,000 pictures, and included 503 pictures from 68 countries – by 273 different photographers. It expressed liberal aspirations as they developed after 1939–45. It stayed in credit until the 1970s when it was increasingly seen as an exercise in wishful thinking and even in false consciousness.

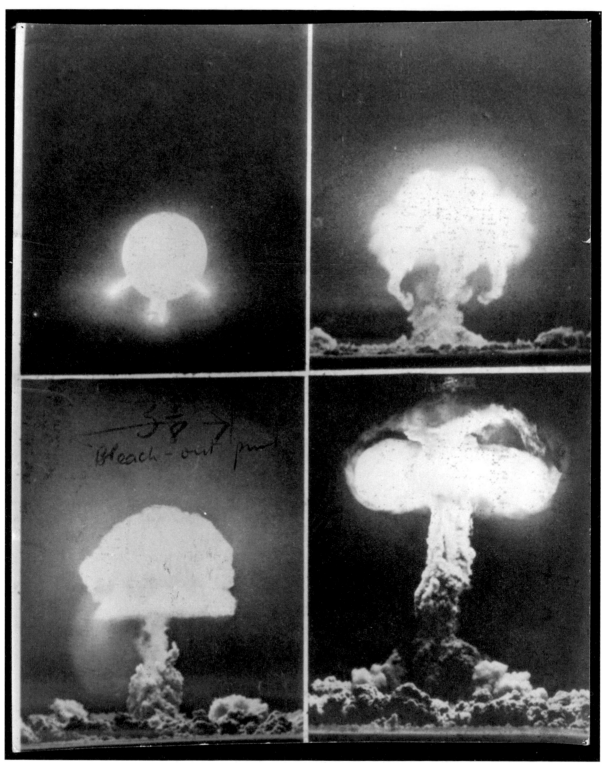

Anon. *America's Biggest Bang, near Las Vegas*, July 1957. Radiophoto. 254mm × 204mm
(from the Collection of the National Museum of Photography, Film & Television)

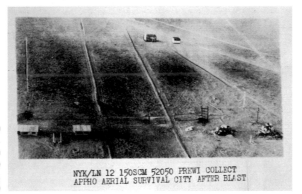

Anon
*Nevada survival city, c.*1952.
Wirephoto. 221mm × 144mm
(from the Collection of the
National Museum of Photography,
Film & Television)

work and made little public impact on the human order, the A-bomb's effects were
as instantaneous and malign as it signature mushroom cloud was ostentatious.
An ultimate development, and stupendous in every respect, the A-bomb imposed
itself on the imagination of the 1940s and 1950s; but that imagination, like any
other faced by a phenomenon which allowed no room for manoeuvre, tired in the
long run.

In this context it is worth recalling the aesthetics of 1914–18: a fixation on
sentience which was sated by the lethal actualities of the War, followed by an era
of artifice. In 1945 and later developments followed a similar kind of trajectory: a
surfeit of reality, as absolute and total as that provided by the Promethean A-bomb
and then more artifice, in the shape of the late modernist Pop Art of the 1960s.

The Age of Transmission

In the 1920s photography provided an accessible way out of the aesthetic of
sentience. It was principally a monochrome medium and monochrome, because it
was free from the flavours of the material world, tended to abstraction. In the
1940s and 1950s, on the other hand, monochrome photography was itself part of
the problem to be overcome, because it had been refined to such a degree that its
reports looked as if they had substance. It could easily be viewed as offering a
transparent window onto actualities, even if it still pictured them in black and
white. The way out and into artifice depended on imperfect and degraded media, in
particular on televison. which in the 1950s was beginning to establish itself in the
USA and in Europe. Something which might be called the Age of Transmission came
into view, bringing with it a whole range of imperfectly registered imagery borrowed
from screens and lifted from cinematography. The A-bomb was itself one of the
first post-War topics to be treated this way; by presenting it as a series of images
extracted from film an impression of distance and even of control was achieved.

Typical motifs from the Age of Transmission include series of A-bomb detonations
taken from cinematographic records, space-walks recorded from Russian television

Anon
*Photograph of the first television
broadcast, taken from the
television screen, c.* 1936.
Silver gelatin print.
170mm × 108mm
(from the Collection of the
National Museum of Photography,
Film & Television)

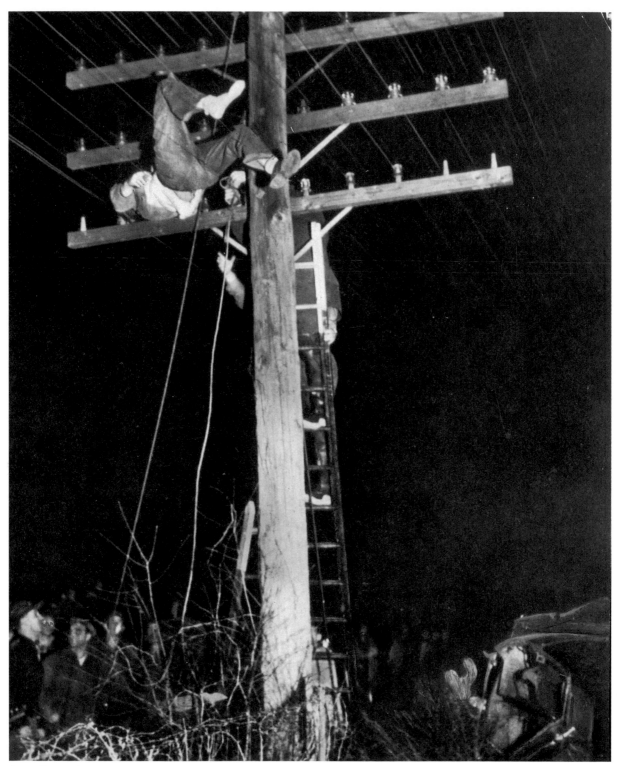

Anon. *Firemen freed him but he died in hospital 30 minutes later.* Wirephoto, USA, *c.* 1946. 190mm × 130mm
(from the Collection of the National Museum of Photography, Film & Television)

Anon. *Plane crash*, Flatbush district, Brooklyn, USA.
December 1960. Radiophoto.
254mm × 204mm
(from the Collection of the National
Museum of Photography, Film & Television)

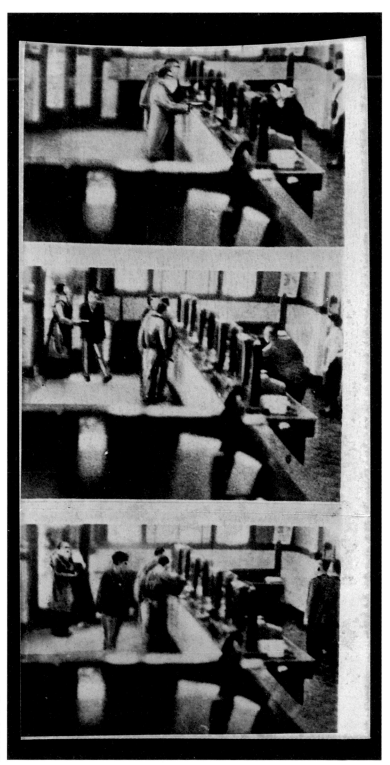

Anon
Still of a Bank Hold-up from a Hidden Ciné Camera,
Cleveland, USA, April 1957. Wirephoto.
304mm × 152mm
(from the Collection of the National
Museum of Photography, Film & Television)

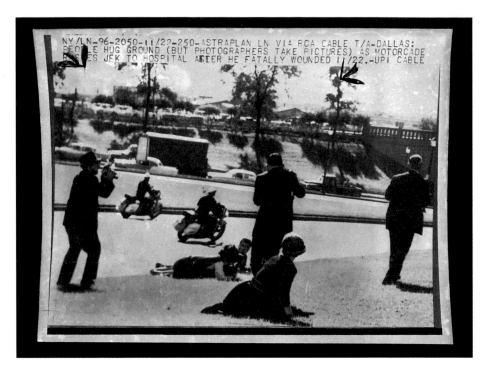

Anon. Film still. *Assassination of President John F. Kennedy*, November 1963. Wirephoto. 204mm × 254mm (from the Collection of the National Museum of Photography, Film & Television)

screens, wirephotos of the aftermath of air and rail catastrophes and surveillance pictures of armed robberies and hostage-taking, mainly in the USA (the principal source of post-modern news). Changes in the news genres began during the 1950s. In the 1930s they had been close to documentary, and ideologically committed. Every major event in the 1930s had had political and national overtones. After 1945 these overtones were less in evidence, although this is not to say that news was any the less important in the political economy. News became something like an index of openness and of social vitality and any society could get credit for producing a lot of news coverage. This was something the Communist bloc conspicuously failed to do, giving an impression of entropy which contrasted sharply with the sheer volume of events generated in the USA. It was the function of new news to occupy consciousness on a day-to-day basis, defining citizenship as a roller-coaster ride through a culture of distractions. Events great and small crowded in from all sides, ranging from assassination attempts to straightforward traffic accidents. Such events, especially the ordinary ones, were best served by makeshift printing or by any hurried rhetoric which spoke of urgency, and it was at this time, during the 1960s, that poorly registered wirephotos finally came into their own. It may be tempting to assume that news, in an age of mass communications, is a constant, and that news categories established in the 1940s and 1950s kept their cachet; but it is likely that, when the accounts are finally done, we will find that there was a period of news activism which came to an end in the early 1970s with the conclusion of the Vietnam War.

Vietnam

Vietnam, which has now been secreted in the archives of the world's press agencies, was one of photography's great creations, a late- and sometimes even a post-humanist epic. It stands as a sequel to the work of the American Farm Security Administration, or FSA as it was known, the state documentary venture of the late 1930s which employed, among others, Walker Evans, Dorothea Lange, Russell Lee, Arthur Rothstein and Ben Shahn. Whereas the FSA archive has been cared for, that from Vietnam takes its chances in filing cabinets in temporary accommodation. Much of it exists in wirephoto form, hastily printed and insecurely fixed. Many of its photographers, some of them working for the US army, are uncredited. Vietnam, or the pictorial version of events, was spontaneous and hasty, and put together simply to cover events as they happened. Yet the collective findings of Vietnam's photographers add up to a composite picture on a large scale – photography's version of a 'history painting'.

Vietnam had been a war zone since 1941 when Ho Chi Minh undertook operations against the Japanese occupiers and the French colonial authorities. 'Vietnam', as televised and reported by the world's press, began in November 1961 with the arrival of US forces in numbers, ostensibly to inaugurate 'flood control'. US aircraft were authorized to fly combat missions from December 1961, and in February 1962 the Vietcong shot down its first helicopter. By 1975, when the Vietcong occupied Saigon, 47,244 Americans had been counted killed in action, as well as numberless Vietnamese.

The first sensational picture of the war was taken on 11 June 1963 by Malcolm Browne, a reporter with Associated Press. It was of a Buddhist monk, watched by other Buddhist monks, burning himself to death in protest at government policies. On 2 February 1968 Eddie Adams, another photographer with Associated Press, took an even more spectacular picture of the killing, at point blank range with a pistol, of a Vietcong prisoner by Brigadier General Nguyen Ngoc Loan, the chief of South Vietnam's National Police. Both pictures became Vietnam icons.

It is not clear, however, just how effective even the most remarkable pictures were in shaping opinion either in the US or elsewhere. William M. Hammond, whose book *Reporting Vietnam* (1998) gives a thorough account of American journalism during the war, thinks that pictures of General Loan's atrocity had little immediate effect on public opinion. The execution, which was also filmed by Vo Suu, an NBC News cameraman, was shown on American TV to an audience of around 20 million and drew 56 complaints of bad taste and 34 that it appeared at a time when children were watching. Adam's photograph, printed in most major newspapers, contributed to a debate on atrocities and the mistreatment of prisoners by both sides. It was taken at the height of the Tet offensive, a Vietcong attack on principal cities and towns in South Vietnam which had been timed to coincide with the festival of Tet.

Farm Security Administration

The FSA, as it is generally known, was set up in 1935 to give help to small farmers in the USA. Rural communities had been badly affected by the Depression. Roy Emerson Stryker was appointed to head its Historical Section, and he decided to assemble a photographic archive which could be used to advertise the condition of rural communities, especially in the South. Walker Evans, one of Stryker's first appointments, was already a photographer with a reputation. Ben Shahn was known as an illustrator. The FSA Collection, now housed in the Library of Congress, Washington, is the first great collective work in the medium. It began to be appreciated in the 1970s. The documentary project was discontinued in 1943. Roy Stryker then moved with several of the FSA photographers to work for The Standard Oil (New Jersey) Project.

(LON-5),SAIGON, Oct 26th(AP)=The point of a knife is pressed against the body of a captured Viet Cong guerilla as he is interrogated by South Vietnamese Rangers recently. The prisoner was one of four taken in a riad on the village of Cau Ke in the Mekong River Delta. All were subjected to various forms of torture before revealing location of thirteen concealed weapons. (APWirephoto) (CHJ. Oct 26. Str)(P.24807)

Anon. *Mekong Delta*, South Vietnam, *c*.1965. Wirephoto. 254mm × 204mm
(from the Collection of the National Museum of Photography, Film & Television)

Vietnam is an ambivalent chapter in the history of the American press, which mediated the war for a community doubtful about the wisdom of US intervention. Vietcong tactics took close account of likely press responses, and there was little the US could do about it for freedom of the press was symptomatic of the values under threat from the Communist regime in North Vietnam. During the Korean War in the early 1950s censorship had been in force, but that was a quite different sort of war between regular armies along front-lines. Habits learned in 1939 – 1945 were still in force, and controls accepted by reporters. In Vietnam, by contrast, there was neither a front-line nor any clear demarcation between the enemy and the civilian population. Vietnam was also the first TV war, which meant that some degree of access to hostilities had to be granted. Nevertheless, very little American TV coverage of the war showed heavy fighting and casualties. Television gear, Hammond comments, was cumbersome and difficult to handle in the field. Traditional photography, he might have added, was far more adaptable.

1939 – 1945 was a very diverse war fought across almost all of the earth's land-scapes. With its range of deserts and steppes and atolls it can look like an extended geography lesson. Vietnam was altogether more restricted pictorially. It was fought out within a limited theatre of jungle, paddy fields, villages and colonial suburbs. But from a photographic and pictorial point of view it was even more important that it took place when it did. 1939 – 1945, although in reality more primitive than Vietnam, was a modernist event, imagined by cameramen who had been impressed during the 1930s by the idea of mechanization: aircraft, tanks and *blitzkrieg* in general. Vietnam's photographers in the 1960s had put such modernist stereotypes behind them. They had been schooled, in photography at least, in the kind of ethnological values promoted by the great *Family of Man* exhibition of 1955. Its organisers looked forward to peaceful co-existence amongst cultures world-wide. Buddhist Vietnam was exactly the sort of culture which *The Family of Man* was meant to honour, for its people were pious, tradition-conscious and largely agrarian. In fact, Vietnam exemplified utopia as it had been envisaged by the great documentary photographers after 1945, by Henri Cartier-Bresson, for example, in Indonesia, and by the Swiss Werner Bischof in Japan. Then all of a sudden it seemed as if this exemplification of paradise on earth had been singled out for a demonstration of fire-power unequalled in 1939 – 1945.

Vietnam also coincided, unfortunately for the US, with an anguished backward glance by Americans at their own history. Settlement in the late nineteenth century had dealt severely with native Americans who had been massacred and relocated into submission. Hollywood in the 1950s tried to exorcize this crime against humanity in a series of films in which a noble aboriginal leader (played by, for instance, Jeff Chandler) negotiated with an equally noble Caucasian outsider (such as James Stewart), against a background of cavalry charges and 'Indian' ambushes. The cavalrymen, although ill-led by bigots, were decent at heart. Their opponents were ethnic people, with a taste for biblical English and for elaborate

costumed ceremonies. The 'Indians' in these epics fought semi-naked against opponents who were both more heavily clad and better armed, and this is where the parallel with Vietnam photography begins, for it too featured armoured outsiders and naked autochthons. Hollywood's conscience, as exemplified in Delmer Daves's *Broken Arrow* (1955) and Samuel Fuller's *The Run of the Arrow* (1957), supplied the form in terms of which Vietnam could be read.

The Family of Man was more influential still. It provided not only forms, as Hollywood had done, but an ethical dimension. It set the US up, or put it in an impossibly demanding position. The photography of the FSA, by contrast, was documentary, intended to disclose misfortune amongst small farmers and itinerant workers. FSA pictures couldn't easily be held to blame for false consciousness, whereas sceptics, then and now, had no difficulty in regarding *The Family of Man* as a travesty. It overlooked the commercial and financial infrastructure, the alienating

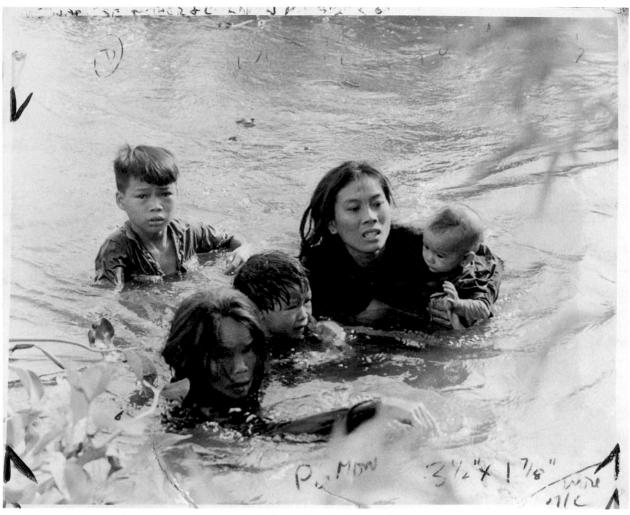

Kyoichi Sawada. *Quinhonx*, South Vietnam, December 1965. Silver gelatin print. 204mm × 254mm
(from the Collection of the National Museum of Photography, Film & Television)

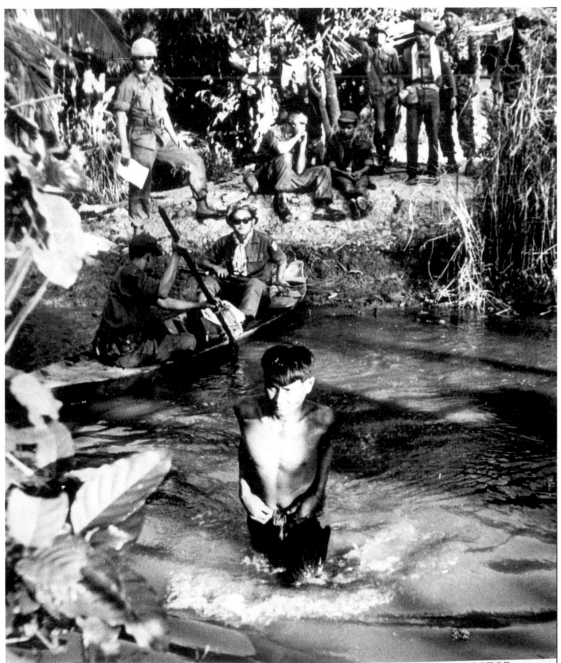

(LON-3) SAIGON, S. VIETNAM, FEB. 8 (AP) — LIVING MINE DETECTOR —
HIS HANDS TIED AT HIS WAIST, A WOUNDED VIET CONG PRISONER IS FORCED
BY HIS CAPTORS, SOUTH VIETNAMESE GOVERNMENT FORCES, TO WADE THROUGH
A STREAM NEAR BAC LIEU IN THE MEKONG DELTA AREA AS A PRECAUTION
AGAINST MINES AND BOOBY TRAPS. THE GUERRILLA, CAPTURED IN OPERATION
EAGLE FLIGHT BY A GOVERNMENT RANGER BATTALION RECENTLY, LATER DIED
FROM HIS WOUNDS. (AP PHOTO) (AP/TOK. R 3237 080265 RD)

Anon. *Mekong Delta*, South Vietnam, February 1965. Silver gelatin print. 254mm × 204mm
(from the Collection of the National Museum of Photography, Film & Television)

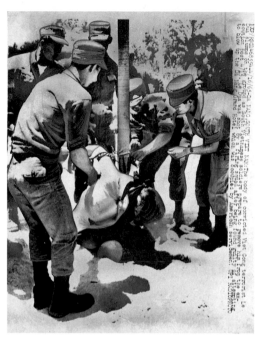

Anon.
Da Nang, South Vietnam, April 1965.
Radiophoto. 254mm × 210mm
(from the Collection of the National
Museum of Photography, Film & Television)

effects of technology, and the presence of injustice and oppression. Even if *The Family of Man* was well meant and a credit to its originators, its pastoral and utopian aspects could not be ignored. Vietnam amounted, as it were, to history's revenge and to a return of all those dark forces repressed in 1955.

The future, as imagined from the standpoint of 1955, would be peaceful and humane. It would centre on family life, and would be conducted in accord with the seasons. Local traditions would endure, safeguarded by High Culture, signalled in *The Family of Man* by grandiloquent quotations from the world's great literature. Vietnam turned the whole utopian conspectus on its head. Man himself, who had featured in 1955 as a provider and genial paterfamilias, began to appear in other colours, borrowed it seemed from Goya's *Disasters of War*, as a tormented grotesque. The ravages of war were in turn accentuated by the imperfections of wirephotography. When not mired and ravaged by incoming fire, warrior Man, heavily equipped, could also look like a monster, hardly even of this planet. Woman, who had tended children and practised handicrafts in 1955, increasingly featured as a refugee, weighed down by bundles and shepherding bewildered youngsters. Vietnam photographs emphasized the difference between atavistic Man and compassionate Woman. Technology, which had also been kept at a distance in 1955, returned with a vengeance in the 1960s, in lethal guise, epitomized by svelte aircraft impressively named after beasts of prey, and by armoured vehicles, like tracked fortresses, heaped with dead and wounded. The mutual assistance imagined in 1955 degenerated into mistreatment and torture. More subtly, Vietnam as photographed looked like a place without seasonal variation, like a

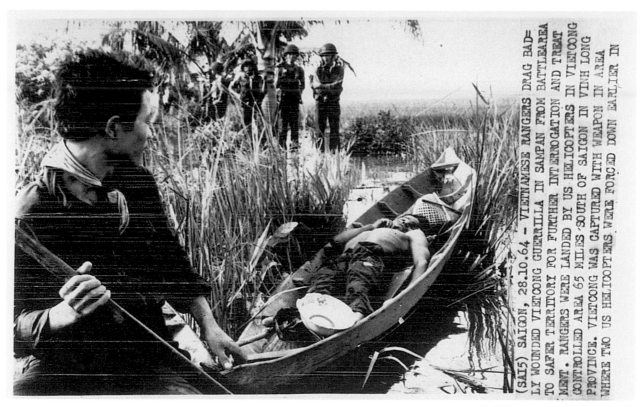

The image carries the following radiophoto caption text:

(SAI5) SAIGON, 28.10.64 — VIETNAMESE RANGERS DRAG BAD= LY WOUNDED VIETCONG GUERRILLA IN SAMPAN FROM BATTLEAREA TO SAFER TERRITORY FOR FURTHER INTERROGATION AND TREAT MENT. RANGERS WERE LANDED BY US HELICOPTERS IN VIETCONG CONTROLLED AREA 65 MILES SOUTH OF SAIGON IN VINH LONG PROVINCE. VIETCONG WAS CAPTURED WITH WEAPON IN AREA WHERE TWO US HELICOPTERS WERE FORCED DOWN EARLIER IN

Anon
Vinh Long Province, South
Vietnam, October 1964.
Radiophoto.
204mm × 254mm
(from the Collection of the
National Museum of Photography,
Film & Television)

continuum of jungle and water in which temporal measurements had to be made arbitrarily, counted out on an individual basis.

The Vietnam War was, by all accounts, a catastrophe. Yet its photographic record must be seen in another light and understood as a last attempt to disclose humanity to itself. If *The Family of Man* was a beautifully realized dream, Vietnam was a brutal clearing of the decks to reveal Man *in extremis* exposed to primitive pressures quite incompatible with the comfortable cultures of the developed world. Left to his own devices post-modern Man, equipped as never before with the means to re-present, tended to imagine worlds apart which were also fools' paradises. To all this easily realized visionary stuff Vietnam was a rude corrective and a reminder too of a formative stage in human history when conduct was shaped in crisis. It can look, from an art historian's point of view, like a recuperation of the (humanist) Renaissance when art was also configured around baptisms, martyrdoms and family flight.

Post-photography

At the same time as 'Vietnam' was arranging a coda to the history of Man, a rebirth was being imagined elsewhere, in connection, particularly, with Space. In the early 1950s the forthcoming space age was being visualized by illustrators.

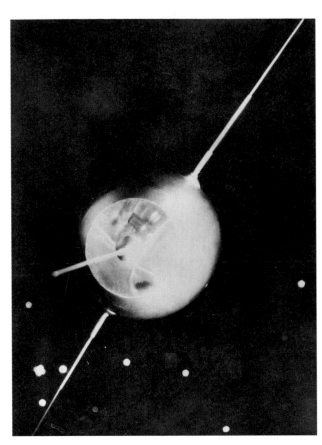

Anon
This is it! Sputnik, Oct. 1957. 'Telephoto'.
281mm × 214mm
(from the Collection of the National
Museum of Photography, Film & Television)

Anon
Soviet Cosmonaut on VOSKOD-2, 1965.
Wirephoto. 204mm × 279mm
(from the Collection of the National
Museum of Photography, Film & Television)

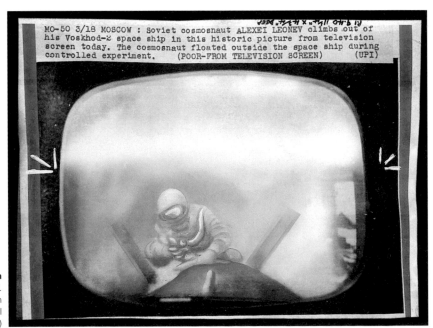

MO-50 3/18 MOSCOW : Soviet cosmosnaut ALEXEI LEONEV climbs out of
his Voskhod-2 space ship in this historic picture from television
screen today. The cosmosnaut floated outside the space ship during
controlled experiment. (POOR-FROM TELEVISION SCREEN) (UPI)

Harry Gruyaert. *Weight Lifting*, Munich, 1972.
Cibachrome print. 305mm × 408mm (Harry Gruyaert/Magnum Photos)

Harry Gruyaert. *Show Jumping*, Munich, 1972. Cibachrome print.
305mm × 408mm (Harry Gruyaert/Magnum Photos)

above and right:
Harry Gruyaert. *Athletics*, Munich, 1972. Cibachrome prints.
305mm × 408mm (Harry Gruyaert/Magnum Photos)

Mars Pathfinder, an image
from NASA television, July 1997.
A view of the surface of Mars
shows the spot (above the pink
arrow) where scientists believe
the Pathfinder probe to have
landed in July 1997
(AP Photo/NASA TV)

The distinguished Chesley Bonestell, illustrator of *The Conquest of Space* and designer for the motion pictures *Destination Moon* and *When Worlds Collide*, used a quasi-photographic style to depict what look like prototype Stealth bombers gliding through the starlit interplanetary night. His co-illustrators in *Across the Space Frontier* (1952) were Fred Freeman and Rolf Klep, who had both worked for the US Navy during W.W.II, and who specialized in cutaway drawings of complex installations: aircraft carriers and power plants. Their visions held good, up to a point, although their tendency was to imagine space conquered and effortlessly inhabited. Their 'futuristic' visions set an agenda, but in the short term Space delivered pictures of humanity disabled in an alien environment. The Russians, who, in the shape of Yuri Gagarin, had sent the first man into space (12 April 1961) seem at first not to have considered the photographic potential of their space missions. The first (hand-held) photograph of the Earth from Space was taken on 7 August 1961 by Gherman Titov, the first man to spend a day circuiting

Japan Deep, Sagami Bay, Japan, July 1997. An electronically registered image of a 5-metre-long physonect siphonophore jellyfish at a depth of 800-900 metres. Taken from *Dolphin 3K*, a Japanese submersible device (Associated Press JAMSTEC)

the Earth. Titov's picture of the cloud-covered globe was taken using a Konvas camera and it looks like the work of a day-tripper out to capture a keepsake for family and friends. There have been any number of firsts in space exploration, and the first space walk was undertaken from the Voskhod 2 (Voskhod = Sunrise) on 18 March, 1965 by Alexei Leonov during a flight of 17 orbits over 26 hours. Attached to a 16-foot tether, Leonov had trouble manoeuvring, and at one point was rotating at the rate of ten times per second. Leonov's space walk of ten minutes was recorded on television and the results broadcast as 'video grabs' or extracts. The video style, which looked like primitive wirephoto in motion, emphasizes Leonov's vulnerability, and the precariousness of the enterprise. (In the course of the walk Leonov's spacesuit ballooned and he had trouble re-entering the space-craft.) On 16 July 1969, Americans from Apollo 11 landed on the Moon, and took pictures far more accomplished than anything achieved during Leonov's mission. The difference can be explained by technological advances, but at the same time

Driving Rover, Los Angeles,
United States, *c.* 1997. A digitally
modified photograph from Mattel
showing the Mattel 'Hot Wheels
Sojourner Rover Action Pack'
(Associated Press Mattel)

Japan Deep,
Sagami Bay,
Japan, July 1997.
An electronically
registered image
of an Atolla
jellyfish at a depth
of 620 metres,
with long tentacle
trailing. Taken
from *Dolphin 3K*,
a Japanese sub-
mersible device
(Associated Press
JAMSTEC)

Mars Pathfinder. A digitally produced artist's rendition created January 1996. NASA is sending *Sojourner*, an unmanned, microwave oven-sized rover (lower left) to roam across the surface of Mars to analyze rocks and weather conditions (AP NASA/JPL)

Erich Hartmann
Quarks series, 1981:
West Hall of the CERN (European
Centre for Nuclear Research) complex,
Switzerland. The Hall is stacked with
concrete blocks to protect sensitive
detectors that monitor particles
emerging from CERN's high-energy
beams. Their thick concrete prevents
stray radiation produced in any
particular experiment from
distorting other investigations.
Cibachrome print. 279mm × 356mm
(Erich Hartmann/Magnum Photos)

Leonov's performance reflects the late humanist style of the 1950s and early 1960s, that of the early Pop of Robert Rauschenberg and of Red Grooms, whereas the Moon landing with its Lunar Module and Lunar Rover buggy resembles a late 1960s tableau in the style of Duane Hanson, for example, or Ed Kienholz, an instance of furnishing rather than of expressive representation.

Photography, as it had been understood from the 1920s through into the 1950s, lost ground to new quasi-photographic technologies in the 1960s. Earth satellites, put into orbit from the late 1950s onwards, carried such sensors as the Multi-spectral Scanner Subsystem (MSS) which scanned the ground below in both the visible spectrum and the infra-red. Vast numbers of these pictures were taken, of the entire surface of the earth, giving information on geological faults, pollution and crop conditions. Earth-resources imagery, as with most advanced and science-based photography in the post-modern era, made use of false colours, ostensibly for ease of understanding. Aerial landscapes in vivid primaries may be coded to give information on industrial pollution, but above all they look attractive, like foodstuffs in close-up. All of these new computer-generated pictures of the 1970s and 1980s originated in scientific research, much of it funded by public bodies and all of it very expensive. This means that published pictures of geographical and scientific wonders have also to be understood as publicity stills devised to sell the idea of research and development as activities desirable in themselves.

In former times new developments were introduced raw, and left to make an unpredictable impression. In the post-modern era, on the other hand, novelties have been stage-managed into line with contemporary styling so that a DNA molecule, for instance, might well look like the icing on a cake. For a marvel to

Erich Hartmann. *Quarks series*, 1981: a moonlit view of the CERN (European Centre for Nuclear Research) accelerator complex, Switzerland. Cibachrome print. 279mm × 356mm (Erich Hartmann/Magnum Photos)

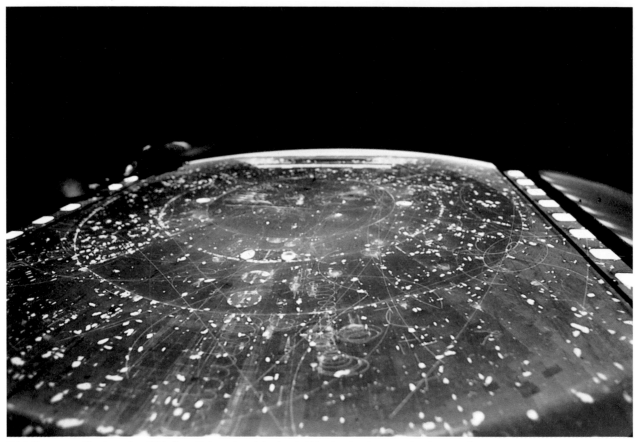

Erich Hartmann. *Quarks series*, 1981: the collisions of particles in a bubble chamber, interpreted on large reading tables, at the Fermi National Accelerator Laboratory, USA. Cibachrome print. 279mm × 356mm (Erich Hartmann/Magnum Photos)

function as such it must be genuinely surprising, not just part of a class of brightly coloured 'wonders of science'. On the other hand, it is doubtful if this innovative photography is meant to be taken objectively. It looks rather like a metaphoric art intended to do justice to the workings of the imagination. Printed into a catalogue or magazine it might appear to be continuous with photography, a debased post-modern variant of the photomicrography of the 1860s, for instance. But the printed page is as much an alien environment to this kind of 'photography' as it is to the stereocards of the nineteenth century. Stereocards may have been objects, but they were valued because they gave rise to startling illusions of depth. Screened images make other sorts of claims to attention. Many of them, from the outer limits of science and astronomy, are scarcely illusionistic at all, for if a representation is to be seen as an illusion it must be of something previously known to the viewer. The result is an art of equivalents, or projections of what some remote part of the biological substructure might be imagined to look like. Any participation in this projected reality amounts to an act of the imagination, and emphatically so because it involves personal and subjective contact with a screen, as private as the relationship between viewers and stereocards once was.

New and scientific photography in the post-modern era presents us with images of the imagination in action, inventing figures for what was previously unimaginable. The world which has emerged has cosmetic qualities, and enough of them to have broken the long-standing connection between experimental photography and the avant-garde. Indeed, the saccharine aspects of this kind of image-making may explain the objective and sometimes crude look of post-modern 'art' photography, an art disinclined to go beyond the look of objects, and intent on denying that post-modern idea of the imagination as a branch of interior decoration.

The National Museum of Photography, Film & Television would like to thank Dorothy Bohm for her support of the publication of this catalogue.

Published by the National Museum of Photography, Film & Television, Bradford, England (Part of the National Museum of Science & Industry).

Further information about the Collections at the National Museum of Photography, Film & Television, and details of the Museum's research facilities, can be obtained from the Curator (Collections Access) at the National Museum of Photography, Film and Television, Bradford, BD1 1NQ, telephone 01274 202050, fax 01274 723155, email: b.liddy@nmsi.ac.uk.

Reproduction rights for images from the National Museum of Photography, Film & Television, or the Science Museum, can be obtained from the Science and Society Picture Library, London, telephone 0171 938 9750, fax 0171 938 9751, email: piclib@nmsi.ac.uk.

Design Herman Lelie
Typesetting Stefania Bonelli
Production coordinator Uwe Kraus
Printed in Italy

Front cover: J. M. Eder & E. Valenta. *Two Frogs*. Photogravure, 1896
Back cover: Kyoichi Sawada. *Quinhonx*, South Vietnam, December 1965

ISBN 0 948489 60 X